BRUSHWORK DIARY

WATERCOLORS OF EARLY NEVADA

Brushwork Diary

ARTWORK BY WALTER S. LONG

TEXT BY MICHAEL J. BRODHEAD & JAMES C. McCORMICK

UNIVERSITY OF NEVADA PRESS ▲▲ RENO AND LAS VEGAS

For the citizens of the state of Nevada, past and present, and all their friends nationwide and worldwide, as our part in preserving the heritage of this great state.

MINORCO (USA)

and

INDEPENDENCE MINING COMPANY INC.

Publication of this book was made possible by a generous grant from Minorco (USA) and the Independence Mining Company Inc.

The artwork in this volume is reproduced full size from originals in the possession of the Special Collections Department, Library, University of Nevada, Reno.

The paper used in this book meets the requirements of American National Standard for Information Services— Permanence of Paper for Printed Library Materials, ANSI z39.48-1984.

Library of Congress Cataloging-in-Publication Data

Long, Walter S. (Walter Sully), 1842–1907.
 Brushwork diary : watercolors of early Nevada / artwork by Walter S. Long ; text by Michael J. Brodhead & James C. McCormick.
 p. cm.
 Includes bibliographical references.
 ISBN 0-87417-174-1 (alk. paper)
 1. Long, Walter S. (Walter Sully), 1842–1907—Themes, motives. 2. Nevada in art. I. Brodhead, Michael J. II. McCormick, James C. III. Title.
ND1837.L66A4 1991
759.13—dc20 91-12179
 CIP

University of Nevada Press, Reno, Nevada 89557 USA
Copyright © 1991 University of Nevada Press
All rights reserved
Designed by Richard Hendel
Printed in Japan
9 8 7 6 5 4 3 2 1

FOR

HWA-DI

AND

LORETTA

CONTENTS

ILLUSTRATIONS

PREFACE

Walter S. Long probably had no illusions that his watercolor sketches of Eureka, Tempiute, and other localities of central Nevada's nineteenth-century mining frontier would be treasured as great art. Nevertheless, his artistic efforts have provided later generations with a singular record of the last century's mines and mining communities. His highly personal intentions and his disciplined approach to documenting out-of-the-way sites blend to create a body of work that is both compelling and informative.

The sketches done in and around Tempiute are particularly valuable from the historical standpoint. No conventionally trained landscapist of that time could have been induced to set up his easel in such locations. In the first place, these areas were remote and difficult to reach. But an even more serious drawback was that they lacked streams, lakes, and other bodies of water; the rules of nineteenth-century American landscape art demanded that the scene have water. Not until the twentieth century did trained artists begin to take a dry desert region such as the Great Basin on its own terms.

Meanwhile, there was nothing to prevent an amateur such as Long from making casual, unpretentious sketches of the isolated, relatively arid areas in which he lived and worked. His studio was located where he happened to take a notion to sketch, and many of his studies of mine sites, city streets, and desert terrain were accomplished in the course of his professional activities as a surveyor.

By the 1870s photographic images of these places were entirely possible – observe, for example, the work of Timothy O'Sullivan. But O'Sullivan was a paid employee of well-organized federal explorations; a free-lance photographer of that time would have found it neither professionally nor financially rewarding to trek over miles of forbidding terrain, burdened with the cumbersome photographic equipment of that day, to set up operations in sparsely populated camps such as Tempiute. Eureka's talented photographer, Louis Monaco, seems to have confined his efforts to his own well-settled, prosperous community and its environs.

For those seeking a fuller historical understanding of central Nevada's late-nineteenth-century mining frontier, Long's modest renderings have some advantages over the work of photographers and more gifted painters. A Louis Monaco can give us an accurate look at the Eureka of the 1870s and 1880s, but only in black and white; Long lets us see the colors of the region's structures and natural features. Professional painters, Charles Christian Nahl for example, portrayed aspects of nineteenth-century Far Western mining life. But the less skilled Long tells us more about actual mining operations than did Nahl – who was primarily concerned with depicting California's mountain scenery and the miners in their leisure hours. Moreover, Long takes us into the cabins and other structures of a mining camp. We learn, for example, that the interiors of the simple dwellings at Tempiute were not always crude or lacking in civilized touches.

The work of artists of greater training and imagination than Long is more pleasing or exciting to behold; yet Long, with his draftsman's eye for detail, offers an unembroidered, unsentimental – and therefore more accurate – description of life on the Western mining frontier.

His watercolors are also a faithful record of the typical. Tempiute moved quickly through

the boom-to-bust cycle, as did the vast majority of that era's mining communities in the Far West. Thus Long's modest scenes give us a better feel for the look of hundreds of camps like Tempiute, as well as of the more substantial centers of mining activity, of which Eureka was characteristic.

Several people have generously given of their time and expertise to make this book a reality. Among those who deserve our special thanks are: Robert E. Blesse, Special Collections, University of Nevada, Reno, Library; Nicholas M. Cady, University of Nevada Press; Kenneth J. Carpenter, formerly of the university library; Russell R. Elliott, Department of History, University of Nevada, Reno; Dale E. Floyd, Office of History, Office of the Chief of Engineers, U.S. Army; Cheryl Fox, Nevada Historical Society; Susan Gallagher, Eureka County Historical Society and Museum; Tim Gorelangton, Washoe County Public Library; Howard Hickson, Northeastern Nevada Museum; Jody James-Smokey, Division of Archives and Records, Nevada State Library; Ken Jones, Sheriff, Eureka County; Edward P. Jucevic; Lenore M. Kosso; Maida H. Loescher, Military Archives Division, National Archives and Records Administration; Alvin McLane, Desert Research Institute; Lee Mortensen, Nevada Historical Society; Loretta Perlizzi; Michael N. Rebaleati, Recorder/Auditor, Eureka County; Margaret Ann Riley, Nevada Historical Society; and Roger Steininger.

Walter S. Long : Soldier, Surveyor, Artist

MICHAEL J. BRODHEAD

On Angel Street, three blocks west of the campus of the University of Nevada, Reno, is a small, well-tended cemetery, the final resting place for members of the General O. M. Mitchel Post of the Grand Army of the Republic. Among the Union veterans interred there is Walter Sully Long. His headstone tells that Long had been a major in the 96th Regiment of the United States Colored Infantry.

Long, like almost all other officers of the Union's black units, was white. Despite his relatively high rank (the highest of all those buried there), his military career was not particularly distinguished. At best, his service record was mixed and his association with the army ended in personal disgrace. Nevertheless, Long's military history provides most of the details of the life of a man who would later lead a useful life surveying – and occasionally sketching – Nevada's mining frontier.

Little is known of Long's early years, other than that he was born in Baltimore[1] on May 1, 1842, and that he lived in Baltimore, Cincinnati, and Georgetown before his war service.[2]

1. The 1880 manuscript census for Eureka County, Nevada, lists his place of birth as Ireland. All other sources, however, say Baltimore.
2. Questionnaire of October 17, 1904, W. S. Long Pension Application File, XC2-504-827, Military Archives

Sometime during his youth he received sufficient – but probably informal – training to become a civil engineer.

During the Civil War, loyalties in the nonseceding slave state of Maryland were divided, but young Walter attached himself to the Union cause, at first in a civilian capacity. When the conflict began, and while still a teenager, he was already working for the army Corps of Engineers as a civil engineer in the construction of the Washington Aqueduct. After the outbreak of hostilities Long served as a "civil Assistant Engineer" in the construction of the defenses of Washington, D.C.[3]

From March of 1862 until actually donning a uniform the following year, Long performed engineering duties in several Union army commands. According to a summary of his army record compiled by the assistant adjutant general, he "participated" in several battles, was "present" at others, and "took part in" the battles of South Mountain and Antietam. He was then placed on the staff of George B. McClellan, commander of the Army of the Potomac, and "was engaged in all the reconnaissances made at that time."[4]

Branch, National Archives and Records Administration, Washington, D.C. Hereinafter cited as Long Pension Application File.

3. John Cunningham Kelton, "Military History of Bvt. Captain *Walter S. Long* 1st Lieutenant late 40th Infantry," (n.d., 1869?), in W. S. Long Compiled Military Service Record, Military Archives Division, National Archives and Records Administration, Washington, D.C.

4. Ibid.

One of the results was a manuscript map of the ground occupied by Hooker's troops at Antietam, prepared by Long and Lieutenant Washington A. Roebling.[5] (Roebling went on to postwar renown as the chief engineer for the building of the Brooklyn Bridge.)

Long was sent to Harpers Ferry to work on its defenses during November, 1862, and at the close of the year he became assistant to the chief engineer for Major General Nathaniel Banks's Department of the Gulf.

The remainder of Long's Civil War service would be on the Gulf Coast. He was dispatched to Galveston where, in December of 1862, he conducted mapping reconnaissances.[6] In anticipation of a rebel attempt to take the city, he erected two barricades across the head of the wharf at which the Union forces were quartered. On January 1, 1863, he was present during the successful capture of Galveston by Confederate troops and the seizure of the federal steamer *Harriet Lane*. Long submitted a brief, concise report of these incidents to the chief engineer, who believed that Long's barricades had "undoubtedly saved the lives of several of our men."[7]

5. *A Guide to Civil War Maps in the National Archives* (Washington, D.C.: National Archives and Records Administration, 1986), 24. The Long-Roebling map of Antietam appears in *Atlas to Accompany the Official Records of the Union and Confederate Armies*, in 2 parts (Washington, D.C.: 1891–1895), part 1, plate 28-2.

6. Kelton, "Military History of Bvt. Captain *Walter S. Long*"; *Guide to Civil War Maps*, 105.

7. *The War of the Rebellion: A Compilation of the Official Records of the Union and Confederate Armies*, 70 vols. in 128 parts, and atlas (Washington, D.C.: Government Printing Office, 1880–1901), ser. 1, 15:204, 208. Hereinafter cited as *Official Records*.

He transferred to New Orleans on January 29 and shortly thereafter participated in the movement against Port Hudson and in the engagement at Fort Bisland.

It is not certain to what extent his participation in these engagements involved actual combat. Although his responsibilities were mostly of an engineering nature, for a civilian Long was unusually close to some heavy fighting. After entering actual military service the nature of his duties appears to have changed but little. On June 25, 1863, at Port Hudson, he received a commission as a captain of a black regiment, the First Louisiana Engineers (later redesignated the 95th Regiment United States Colored Infantry), of the Corps d'Afrique.[8] Although technically an infantry unit, the regiment was used for constructing and repairing fortifications, bridges, and roads, and its officers were required to have experience in engineering.[9]

Physically the young captain was five feet, seven inches tall, with gray eyes and fair complexion (ruddy in later life).[10] Instead of immediate duty with the First Louisiana, Long continued to be engaged in engineering assignments for General Banks. He was first sent to Donaldsville, Louisiana, then being threatened by Confederate forces; presumably he was involved with improving its defensive works.

8. Francis B. Heitman, *Historical Register and Dictionary of the United States Army, from Its Organization, September 29, 1789, to March 2, 1903*, 2 vols. (Washington, D.C.: Government Printing Office, 1903) 1:640; *Official Army Register of the Volunteer Force of the United States Army for the years 1861, '62, '63, '64, '65*, part VIII (Washington, D.C.: Secretary of War, 1867), 276.

9. Captain John C. Palfrey to Lieutenant Colonel Richard B. Irwin, June 27, 1863, Record Group 94, Regimental Papers, 95th U.S.C.T.

10. Declaration for Pension form, Long Pension Application File; Questionnaire of October 17, 1904, ibid.

Later that summer a new regiment of the Corps d'Afrique, the Second Louisiana Engineers, was formed at New Orleans. On August 26, Long was transferred to it, with the rank of major. Again, however, he was put on detached service, having charge of the defensive works at Port Hudson until April of 1864. That month his regiment was redesignated the 96th U.S. Colored Infantry. In the following spring Long and the 96th participated in Banks's failed Red River campaign and the retreat from Alexandria, Louisiana, with Long serving as acting chief engineer of the Department of the Gulf.[11]

Upon returning to New Orleans, he became engineer in charge of fortifications at Camp Parapet, Louisiana, until September 5, 1864, at which time he was given charge of fortifications at Brashear City. In a February 21, 1865, communication Long reported his progress in constructing the defenses of the post there: "The water battery has been completed. . . . The redoubt has the earth-work nearly to the full height. . . . The infantry parapet of the connections is about one-half completed, revetted, and trimmed."[12]

Early in 1865 Long rejoined his regiment, which was then at Mobile. But on May 28, 1865, he was ordered to report to the chief engineer of the Military Division of West Mississippi and sent to Shreveport, where from June 4 until August 21 he was acting engineer.[13] He returned to his regiment (with which the 73d U.S. Colored Infantry was consolidated, September 23, 1865) and remained with it until it was mustered out on January 29, 1866. Rather than returning to

11. Kelton, "Military History of Bvt. Captain *Walter S. Long.*"
12. *Official Records*, ser. 1, 48, part 1:710.
13. *Official Records*, ser. 1, 49, part 1:105, 140, and part 2, 925.

civilian life immediately, Long was retained as "special Judge Advocate of Military Commission at New Orleans" until April 15.[14]

Sometime in the course of the war he received a head wound. Also, according to his pension application, two toes of his left foot had been amputated; it is not clear if this occurred during or as a result of his participation in the war.

Walter S. Long's Civil War service was apparently commendable. As civilian and soldier, his engineering skills served the Union cause well. Yet the record is not without blemish. He was regularly in trouble for breaches of military discipline. On October 21, 1863, at Port Hudson, he used "violent language" to a sentinel, threatening to "run [him] through." This resulted in a court-martial, February, 1864, in which he was found guilty of the charge of "conduct prejudicial to good order and military discipline" for his "gross misconduct towards a colored sentinel." As punishment, he was suspended from rank and command for a month, with pay forfeited, and was to be reprimanded by the commanding general. The commander of the Corps D'Afrique also reported that a camp under Long's charge was in a "filthy condition" and recommended that he be relieved of duty at Port Hudson.[15]

A second offense was even more serious. This time he directed his short temper at his superiors. In October of 1863 he failed to pass an examination for promotion to lieutenant colonel and vented his wrath on the promotion board. A court-martial found him guilty of "abusive

14. *Official Army Register of the Volunteer Force*, 277; Kelton, "Military History of Bvt. Captain *Walter S. Long.*"

15. Brigadier General George L. Andrews to Brigadier General Charles P. Stone (Banks's chief of staff), December 24, 1863, Long Compiled Military Service Record; muster rolls, ibid.

language" to the board, which constituted conduct unbecoming an officer and a gentleman.[16]

The record does not say what, if any, punishment the court imposed. But in April of 1864, Long was under arrest pending the sentence of a court-martial for this, or perhaps some other infraction. On December 21, 1864, he was tried by court-martial and found guilty of insubordinate conduct; the sentence was suspension for two months. In April of 1865 he was unable to report to his regiment as ordered because he had been suspended from rank and pay by a sentence of a general court-martial in February, for yet another breach of regulations.[17]

Considering his many clashes with authority, it is surprising that Long escaped demotion or dismissal. More surprising is that he chose to remain in the army after the war and that the army permitted him to do so. Following a brief turn as a civilian (during which time he may have returned to Baltimore), he received a commission in the regular army on October 1, 1866, as a second lieutenant in the 40th Infantry. The commission was backdated to July 28, the day on which Congress authorized the formation of this and five other black regiments. Commanded by Colonel Nelson A. Miles, the 40th was garrisoned in various areas of the South during Reconstruction. On March 3, 1869, it was consolidated with the 39th Infantry to form the 25th Infantry, U.S. Colored Troops.[18]

The nature of Long's duties is not known, but presumably they were the routine functions

16. Muster rolls, Long Compiled Military Service Record.

17. Kelton, "Military History of Bvt. Captain *Walter S. Long*"; muster rolls, Long Compiled Military Service Record; Long to Lieutenant Colonel R. B. Irwin, April 14, 1864, ibid.

18. Heitman, *Historical Register* 1:135, 640; Kelton, "Military History of Bvt. Captain *Walter S. Long*."

of a company grade infantry officer in peacetime. At first all went well. On March 2, 1867, he received a double brevet, to first lieutenant and captain, in recognition of his "gallant and meritorious service in the battle of Antietam, Maryland, while attached to the army as [a] civil engineer." Meanwhile, he was ordered to report to the army's Board for the Examination of Candidates for Promotion. Long's widowed mother wrote a letter to the presiding officer, introducing her son and informing the general that young Walter had served "during the whole of the late war of the rebellious states against the union, partly as Engineer in the 19th Corps under Gen'l McDowell and Banks and afterwards as major in the U.S.C.I." On July 31 he was promoted to the regular rank of first lieutenant.[19]

Soon, however, his military career was in shambles. While in North Carolina, 1868-1869, three enlisted men entrusted money to Long – amounts ranging from 40 to 60 dollars, some for deposit in banks, others for safekeeping. Rather than do either, Long appropriated the money for his own use and refused to make restitution. He requested permission to return to Baltimore and, on April 22, received orders allowing him to do so. But by June he was under arrest at New Orleans. That month, also in New Orleans, a court-martial arraigned and tried Long on the charge of conduct unbecoming an officer and a gentleman. He pleaded not guilty to the charge and five specifications. The court, believing that "sufficient opportunities were not given to Brevet Captain Long to refund the sums," acquitted him on all counts.

19. Heitman, *Historical Register* 1:640; Cullum, *Biographical Register* 2:83; Mrs. R. Cary Long to Brevet Major General Christopher C. Augur, October 17, 1866, Walter S. Long Personnel File (L111 CB 1869), *Letters Received by the Commission Branch of the Adjutant General's Office, 1863–1870,* National Archives Microfilm Publication M1064, roll 437. Hereinafter cited as *Letters Received.*

More accusations of wrongdoing soon followed. In July he was accused of conduct unbecoming an officer and a gentleman and for violation of an 1863 federal law "to prevent and punish frauds upon the Government of the U.S." Specifically, he was charged with selling his personal payroll for the month of May to a New Orleans pawnbroker (who would then be able to redeem the amount from the army) and then presenting to the paymaster duplicates of his payrolls and requesting payment. To the paymaster's question whether he had "previously sold and transferred his accounts for said month of May, 1869, to any person," Long, with "fraudulent intent," replied that he had not. A general court-martial found him guilty and sentenced him to be dismissed from the service.[20]

As if that were not enough, he was taken before another general court-martial in September. Here again he stood accused of financial transgressions. While serving as the regiment's acting commissary of subsistence at Fort Macon, North Carolina, he had become indebted to the 40th's Company C for the sum of $45.01, "for savings of rations by said company, sold to the Subsistence Department at Fort Macon." In an effort to release himself from the debt, he gave the company commander a check for that amount in March, 1869. Long, however, had no funds in the bank upon which the check was drawn. For this he was charged with embezzlement and, once again, "conduct unbecoming." The court judged him guilty of all charges and specifications. He was to be cashiered immediately and confined for six months or until he refunded the amount embezzled.[21]

20. Court-Martial File PP 526, Military Archives Division, National Archives and Records Administration; Kelton, "Military History of Bvt. Captain *Walter S. Long*."
21. Ibid. (both sources).

After being released and returned to civilian life, Long remained for some years in Louisiana, holding, according to his own testimony, several positions of "trust and honor" in Louisiana state government. In March, 1876, near the end of Reconstruction in Louisiana, he left the South for Boston.[22]

From Boston, in 1877, he initiated a pathetic attempt at reinstatement in the army. To a former officer, whose support he sought, he wrote that his problems in the army were the result of habitual intoxication. Also to blame were "severe personal disappointments" which "had impaired [his] usefulness as an officer." The idleness imposed by having been placed "upon the supernumeracy list of officers 'waiting orders'" after the consolidation of his regiment in the spring of 1869,[23] made him all the more dissolute. As for his drinking, he avowed that he had abstained from liquor for nearly two years.[24]

His correspondent endorsed Long's application in a letter to the secretary of war, noting with apparent skepticism, however, that "He had the habit of drinking. He says he has reformed."[25]

Perhaps realizing that some of his other support would be similarly lukewarm, Long wrote directly to President Rutherford B. Hayes. He reviewed his military career for the com-

22. Long to Lional Allen Sheldon, December 17, 1877, *Letters Received;* questionnaire of October 17, 1904, Long Pension Application File.

23. Heitman, *Historical Register* 1:640.

24. Long to L. A. Sheldon, December 17, 1877, *Letters Received.*

25. L. A. Sheldon to George W. McCrary, December 21. 1877, ibid.

mander in chief and denied any fraudulent intent in the irregularities for which he was cash-
iered. He further acknowledged that drink had been the source of his difficulties and assured
Hayes that he had been cured at the home maintained by the Washington Temperance Be-
nevolent Society (the "Washingtonians," a forerunner of Alcoholics Anonymous) in Boston.[26]
As will be seen later, his problems with alcohol did not disappear completely.

The effort to return to military life failed. Nevertheless, in keeping with the conventions
of the Civil War generation, for the remainder of his life he styled himself, and was addressed
as, Major Long.

It is likely that during this period, perhaps in Boston, he became acquainted with Eliza-
beth C. Parker, the woman to whom he dedicated his Nevada watercolor sketchbooks. That he
was in love with her is clear from his poetic effusion at the beginning of the third sketchbook.
Whatever their relationship, he remained a lifelong bachelor. Bachelorhood, however, did not
necessarily mean celibacy: on a Pension Office questionnaire of 1904 he wrote that he had "no
legitimate child," implying that he was not without issue.[27]

As it did for many another man of his generation who sought to mend broken fortunes, the
West offered the possibility of a fresh start. In 1878, at age 36, Long departed for Nevada,
which would be his home for the remainder of his life. On October 30, in company with "Dr. T.
Stearns" [John Stearns?], also of Boston, Long arrived in Eureka. Stearns may have been a

26. Long to Hayes, November 14, 1877, ibid.
27. Questionnaire of October 17, 1904, Long Pension Application File.

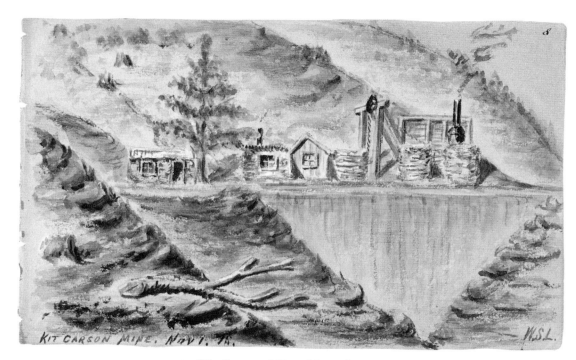

1. *Kit Carson Mine. November 1, 1878.*

brother-in-law, since Long later stated that his sister, Mrs. Maria Stearns of Washington, D.C., was his nearest living relative.[28]

No doubt they had traveled west to Palisade, a Nevada town on the Central Pacific route, and then gone south to Eureka on the Eureka and Palisade Railroad. The two men took rooms at the Jackson Hotel, which boasted of having the "finest bar-room in the state." In Palisade and Eureka Long began painting the watercolor scenes for the first of his three 1878-1880 sketchbooks. Typical of his earliest views was one titled "Kit Carson Mine" (figure 1).

Eureka was fast becoming the state's most productive mining community and the hub of mineral activity in central Nevada. The local newspaper reported that Long and Stearns were "largely interested in the recent purchase of valuable mining property in Tem Pahute District."[29] Departing there early in November, Long, and perhaps Stearns and others, traveled over 135 miles of inhospitable land to Tempiute (as it is now spelled).[30] En route he sketched a few scenes.

28. John Stearns was one of the seven trustees of the Wyandotte Silver Mining Company, in the Tempiute district. Nevada Secretary of State, Record of Incorporations, 1:656, Division of Archives and Records, Nevada State Library and Archives; "Claimant's Affidavit," October 14, 1904, Long Pension Application File.

29. *Eureka Sentinel*, October 31, 1878.

30. Over the years it has also been rendered Tempahute, Tem Pah-Ute, Tem Pahute, Tem Piute, and Timpahute. Some authorities believe that it means "rock water people" in the Paiute Indian language. Helen S. Carlson, *Nevada Place Names: A Geographical Dictionary* (Reno: University of Nevada Press, 1974), 231–232. Various alternative explanations argue for "sick Indian," "rocky butte," and "gonorrhea." Alvin R. McLane points out that the U.S. Geological Survey recognizes three different spellings: Timpahute for the mountain

The Tempiute mining district was situated in eastern Lincoln County, 66 miles west of Pioche, the county seat. Since 1865 Tempiute (originally called the Sheridan district) had experienced a series of short-lived silver booms. The mining district itself was formed January 28, 1869, following discoveries of additional lodes. By 1870 there were about fifty men working the mines. The dismantling of the ten-stamp mill at nearby Crescent in 1871 had caused a severe decline of activity in Tempiute; but by 1878, interest in the area had picked up again and the district enjoyed modest prosperity until about 1880.[31] Long's precise interest in Tempiute is not known. He may well have invested financially in one or more of the mines. It is more likely that his concerns there were of an engineering nature and that he was employed as a surveyor by one of the district's mining companies. In March of 1880 he wrote to the federal commissioner of the General Land Office, inquiring when a claim could be made on a lode located by another party who had failed to make the required expenditures.[32]

Among the early results of his stay was a somewhat inaccurate map of southern Nevada, showing the Tempiute district far west of its actual location (figure 2). He also prepared a map of the Tempiute mining district itself (figure 3). Long played a role in local government, be-

range; Tempiute for the highest summit of the range; and Tem Piute for the mining district. McLane, *Silent Cordilleras: The Mountain Ranges of Nevada* (Reno: Camp Nevada, 1978), 90.

31. Stanley W. Paher, *Nevada Ghost Towns and Mining Camps* (Berkeley, California: Howell-North Books, 1970), 303; Myron Angel, ed., *History of Nevada, with Illustrations and Biographical Sketches of its Prominent Men and Pioneers* (Oakland: Thompson & West, 1881), 486; James W. Hulse, *Lincoln County, Nevada: 1864–1909* (Reno: University of Nevada Press, 1971), 18.

32. *Eureka Sentinel*, May 25, 1880.

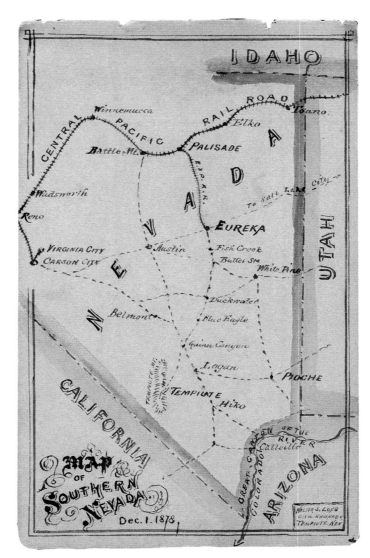

2. *Map of Southern Nevada. December 1, 1878.*

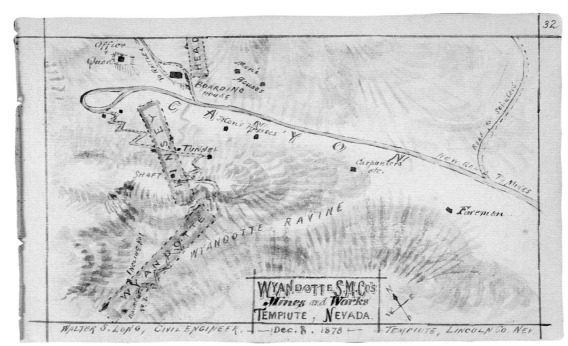

3. Wyandotte Silver Mining Company's Mines and Works.

Tempiute, Nevada. December 8, 1878.

coming Tempiute's justice of the peace on December 6, 1879.[33] Historically, his most notable contributions are the watercolor sketches which depicted Eureka and Tempiute, their environs, and the lands between the two.

Among the principal mining companies operating at Tempiute in the period 1878-1880 was the Wyandotte Silver Mining Company (figures 4, 5, and 6). By 1878 a group of Philadelphia, New York, and Boston investors controlled the company, which was incorporated in Nevada on July 23, 1878. It was capitalized at $10 million, its 100,000 shares of stock selling at $100 each. Its individual mines were the Wyandotte, Kenzie (or Kinsey), Colonel Head, Thompson, and Rattler.[34] Since Long sketched several scenes of the Wyandotte's various mines, it is quite possible that he was in that corporation's employ (figures 7 and 8).

He also sketched another important property, the Inca mine, which the state mineralogist reported as having "had more work done on it than any other mine in the district, having an incline sunk three hundred feet or more." A number of other companies were also active at Tempiute at this time, and by the summer of 1878 about thirty men were working or prospecting in Tempiute and vicinity.[35]

The district's various mines were located in the Tempiute Range, "in a sharp, abrupt hill about six miles long." The Wyandotte mine, the Wyandotte company's most promising prop-

33. Nevada Political Directory: Counties. Nevada Historical Society.

34. *Report of the State Mineralogist of the State of Nevada for the Years 1877 and 1878*, 78–79; Angel, ed., *History of Nevada*, 486; Nafuintah [pseud.], "Tem Pahute District," *Mining and Scientific Press* 40 (January 24, 1880):50; Nevada Secretary of State, Record of Incorporations 1:656.

35. *Report of the State Mineralogist, 1877–1878*, 78–79; Angel, ed., *History of Nevada*, 486; *Mining and Scientific Press* 36 (June 22, 1878):389; ibid. 39 (October 18, 1879):252.

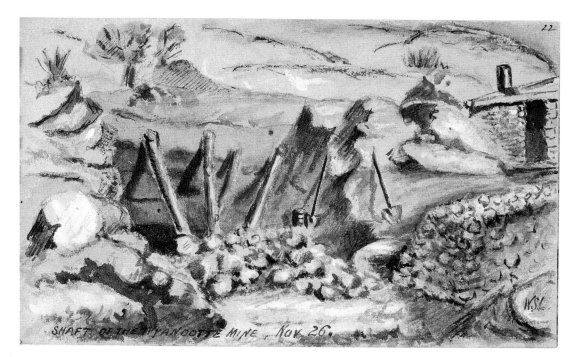

4. *Shaft of the Wyandotte Mine. November 26, 1878.*

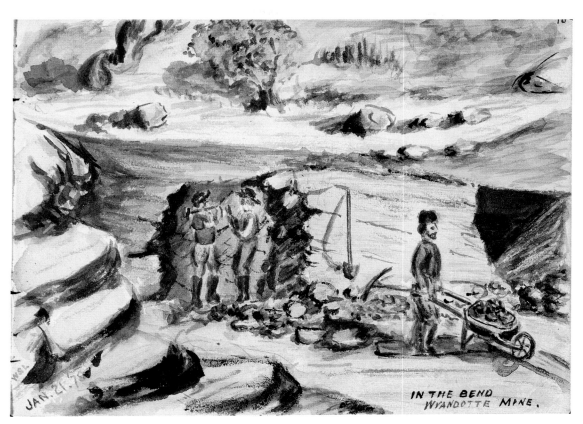

5. In the Bend, Wyandotte Mine. January 21, 1879.

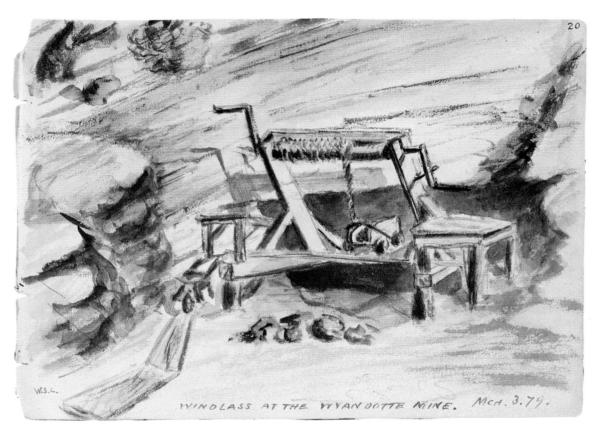

6. *Windlass at the Wyandotte Mine. March 3, 1879.*

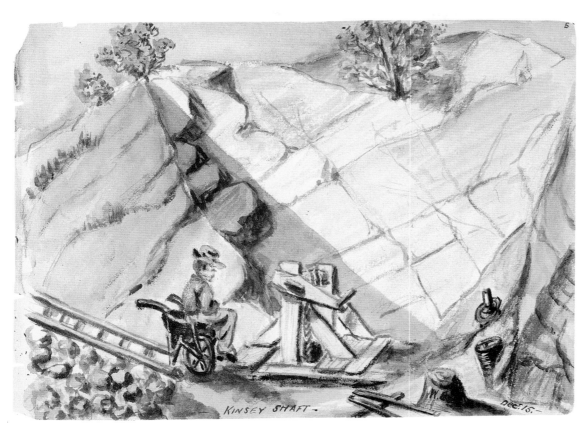

7. Kinsey Shaft. December 15, 1878.

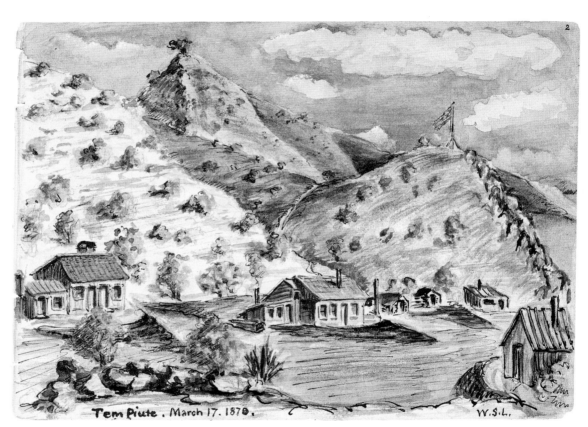

8. *Tem Piute. March 17, 1879.*

erty, was described as "located about half way between the base of the [Tempiute] mountain and the summit, on the west side of the mountain, and shows a well defined quartz ledge, ranging from two to ten feet wide, of good ore." By early 1880 the mine had reached a reported depth of only 150 feet.[36] At its peak of activity the Wyandotte corporation employed about forty men (figures 9 and 10).

Despite the growing interest in Tempiute, the district was plagued by several problems that ultimately dashed all hope of it becoming a major producer of mineral wealth. It was remote from population centers and railroads and was accessible only by primitive roads. Water had to be transported by mules from Tikaboo Springs, seven miles away (figures 11 and 12). The Wyandotte company had announced the purchase of machinery for boring a 1,000-foot-deep artesian well, but apparently the work was never completed. After the closing of the Crescent mill, the ores had to be taken to Reveille, some seventy-five miles distant; the Wyandotte company's intention of erecting a twenty-stamp mill at Tempiute came to nothing. Also, there was a complaint that the Wyandotte's management lacked proper knowledge of mining. In its peak year, 1878, the Tempiute district's minerals had a gross yield of only $5,977.[37] All of these factors contributed to the failure to attract sufficient capital and manpower.

36. Angel, ed., *History of Nevada*, 486; *Report of the State Mineralogist, 1877–1878*, 78; Nafuintah, "Tem Pahute District," 58.

37. *Mining and Scientific Press* 36 (March 9, 1878):149; ibid. 37 (July 6, 1878):5; Nafuintah, "Tem Pahute District," 58; *Report of the State Mineralogist, 1877–1878*, 78. Bertrand F. Couch and Jay A. Carpenter, *Nevada's Metal and Mineral Production (1859–1940, Inclusive)*, University of Nevada Geology and Mining Series, no. 38 (November 1, 1943), 85.

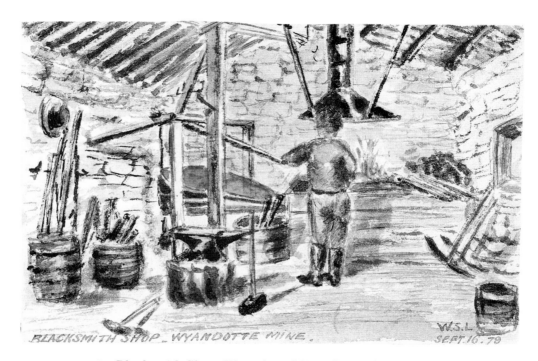

9. *Blacksmith Shop, Wyandotte Mine. September 16, 1879.*

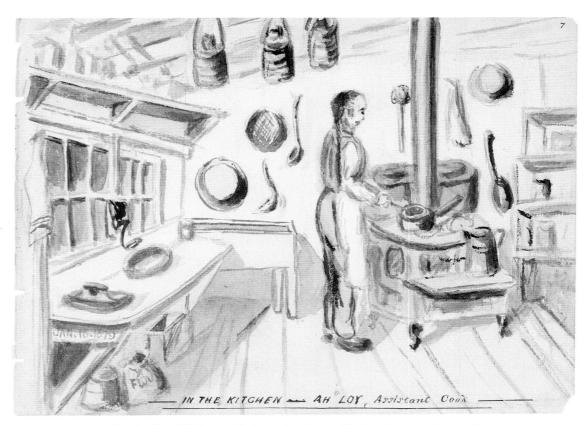

10. *In the Kitchen—Ah Loy, Assistant Cook. January 16, 1879.*

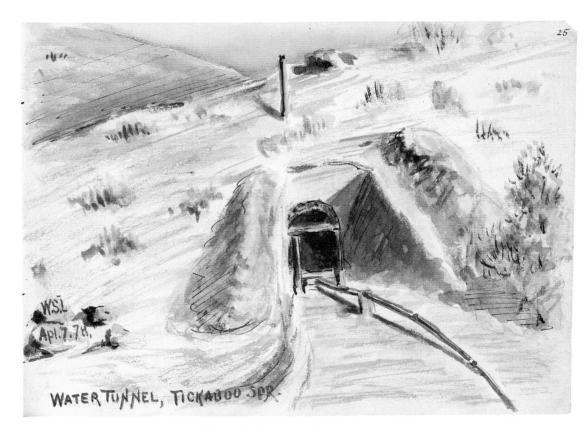

11. Water Tunnel, Tickaboo Springs. April 7, 187[9].

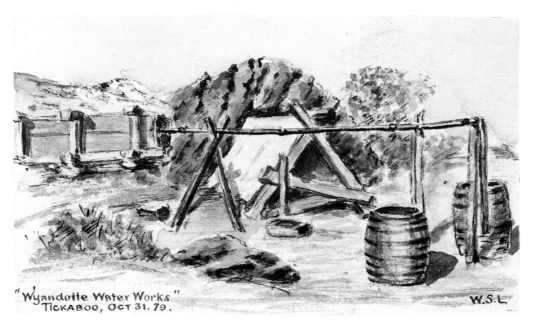

12. "Wyandotte Water Works," Tickaboo. October 31, 1879.

Long joined the general exodus from the district in 1880. On April 5 he resigned as justice of the peace. By May he had settled in Eureka, a thriving mining community of 4,207, according to that year's census. He began advertising his services as a civil engineer and Deputy U.S. Mineral Surveyor, with an office over the Bank Exchange, on Main Street[38] (figures 13, 14, and 15).

In addition to his professional work, he achieved a measure of prominence in the community's social and cultural life. On May 27, 1880, it was announced that the following evening, at the Methodist Episcopal Church, Long would deliver a lecture on "the Fourth Element of Space." The *Eureka Sentinel* expressed confidence that "It will be well worth hearing, and should draw a crowded house." The newspaper further stated that Major Long could be "relied upon for a discourse as interesting as it promises to be novel" and identified the speaker as a graduate of West Point.[39] One wonders if this was simply an editorial error or deliberate misinformation supplied by the speaker.

In June, Long was made secretary of Eureka's committee for organizing that year's Fourth of July celebration.[40] In a time when the Fourth was America's most popular holiday, this was no small honor for Long. Selection for this responsibility shows the degree of respect and acceptance he had achieved after living in Eureka for only a short time.

38. Nevada Political Directory: Counties. Nevada Historical Society; Russell R. Elliott, *History of Nevada* (Lincoln: University of Nebraska Press, 1973), 106; *Eureka Sentinel*, May 7, 1880.
39. *Eureka Sentinel*, May 27, 28, 1880.
40. Ibid., June 20, 25, 1880.

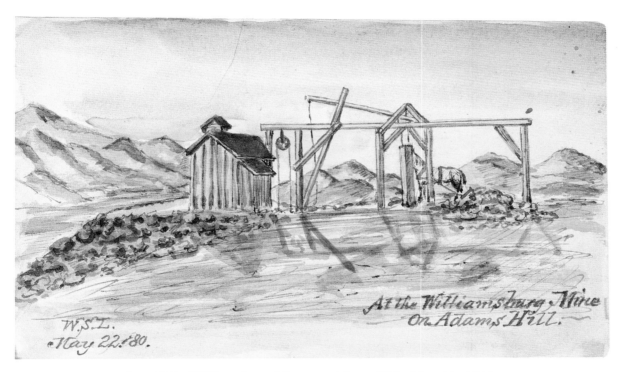

13. At the Williamsburg Mine, on Adams Hill. May 22, 1880.

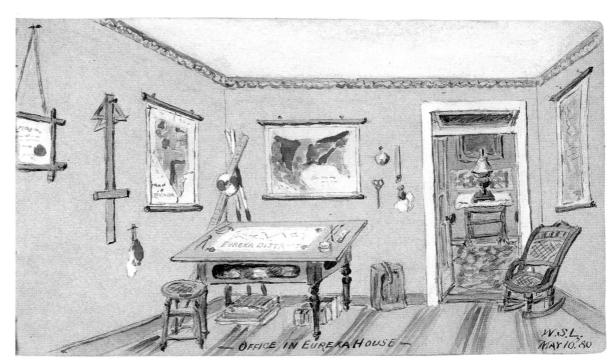

14. Office in Eureka House. May 10, 1880.

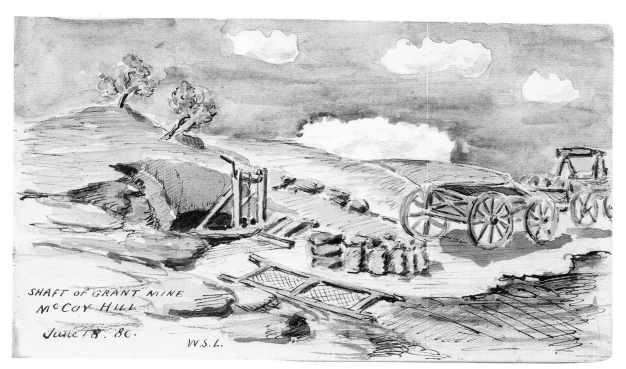

SHAFT OF GRANT MINE
McCOY HILL

June 18. 80.

W.S.L.

15. *Shaft of the Grant Mine, McCoy Hill. June 18, 1880.*

In other respects, his first year in Eureka was marked by at least two disappointments. Even though the Republicans were mostly successful in capturing county offices in the 1880 election, Long, the party's nominee for county surveyor, not only lost but ran well behind the rest of the ticket. Also, his application for appointment as register of the U.S. Land Office at Eureka was unsuccessful.[41]

Such reverses may have contributed to the return of his drinking problem – if indeed it had ever been cured. In any case, on February 19, 1882, he was incarcerated in the county jail for drunkenness. Fortunately, no charges were filed and he was released after three days.[42] He gained his freedom in time for participation in the celebration of yet another important occasion, Eureka's eleventh annual Washington's Birthday ball. The "Hooks and Knicks" (i.e., the Eureka Hook and Ladder Company and the Knickerbocker Hose Company) sponsored the event, and Long was a member of the invitation committee.[43]

For the remainder of the decade the Republican party enjoyed supremacy in Nevada, and Long's political fortunes improved accordingly. He was elected county surveyor in 1882, 1884, and 1886, but lost in 1890 and 1894. He did succeed, however, in his application for a federal pension. Under the terms of an act of June 27, 1890, he was eligible to receive six

41. Ibid., June 30, November 5, 1880; Interior Department Appointment Papers: Nevada, 1860–1907, Roll 2, Land Offices, National Archives Microfilm Publication M1033.

42. Jail Record, Eureka County Sheriff's Office, Eureka, Nevada.

43. *Eureka Sentinel*, February 18, 1882.

dollars a month, which he did, beginning October 4, 1890. Later legislation, of February 6, 1907, raised this to twelve dollars a month, which he began receiving on May 6, 1907.[44]

Failure to retain his county office and the economic decline of Eureka no doubt contributed to his decision to seek brighter prospects elsewhere. He moved to Elko County, probably in 1897. The county was the center of northeastern Nevada's agricultural, ranching, transportation, and mining activities.

The first appearance of his "card" in the *Elko Free Press*, June 19, 1897, announced that Walter S. Long, civil engineer and U.S. Mineral Deputy Surveyor, in Skelton, Elko County, would specialize in mining and irrigation surveying. Skelton (formerly Hylton and, since 1918, Jiggs) was a small community 33 miles south of Elko which served as a "social center" for ranchers in Mound Valley and the surrounding area. A news item in the same issue informed Elkoites that Long, who was a "first class engineer and has had much experience in surveying – both mineral and irrigation," had an office in Skelton and would be opening another in Elko.

Later that year, on October 4, he was appointed to serve out an unexpired term as county surveyor. On March 6, 1899, the death of the incumbent resulted in Long's reappointment to the same post. From his office in the courthouse in Elko he continued to function also as U.S.

44. The first act provided pensions for Union veterans who were "incapacitated for the performance of manual labor"; the second act was for the benefit of Union veterans above the age of 62. Invalid Pension form, Long Pension Application File; *U.S. Statutes at Large* 26:182–183; ibid. 34:879.

Deputy Mineral Surveyor.[45] On April 28, 1900, the *Free Press* reported that Long had recently returned from a surveying trip to Mound and Huntington valleys, and urged those wanting to know anything about Elko County lands – "surveyed and unsurveyed, and those that are occupied" – to consult the full set of township maps available in the Major's office.

Long remained politically active in his days in Elko. In the spring of 1900 he was elected as one of the county's delegates to the Republican state convention, which was to meet in Carson City. In the fall he was chosen to be one of the Elko County members of the party's state central committee.[46]

His participation in Republican politics no doubt played a part in making his Elko sojourn relatively brief. By January, 1901, his appointment as U.S. Deputy Surveyor General had been confirmed by the Commissioner of the General Land Office. His new position would take Long to Reno, where he would spend the remainder of his life.

Later that year, however, a technical difficulty arose that jeopardized his new job. The federal Civil Service Commission notified Matthew Kyle, U.S. Surveyor General for Nevada, and Long's superior, that Joseph H. Drips of Oregon, and not Long, was entitled to this post because Drips had passed the necessary qualifying examination.

Kyle protested in a forceful letter to President William McKinley. He emphasized Long's experience, skill, and faithful performance of duties, and informed the president that his valued deputy was a wounded Union veteran and a loyal Republican. Kyle, ironically, had been

45. *Elko Free Press*, October 9, 1897, March 11, 1899, and January 12, 1901.
46. Ibid., April 4, September 1, 1900.

sheriff of Eureka County in 1882, and it was in his jail that an inebriated Walter Long had languished almost twenty years earlier.[47]

Kyle also prevailed upon Nevada's dynamic Senator William M. Stewart to intercede on Long's behalf with the commissioner of the General Land Office and the Secretary of the Interior. The matter was resolved that summer when the commissioner was informed that Long had indeed taken and passed the required examination. Both Long and Kyle expressed their gratitude to Stewart for his efforts.[48]

The exact nature of Long's duties in the Reno office is not known, but he was usually referred to as the chief clerk.[49] As in Eureka and Elko, he participated in a variety of community affairs. He became a member of the Reno Wheelmen's Club and the local GAR post. When the Nevada Historical Society was formed in 1904, Long – by Nevada standards an old settler – was among the organization's ninety charter members.[50]

Death came on December 10, 1907. That morning Mrs. S. M. Henley, Long's landlady at 745 North Center Street, noticed that her roomer, who had retired early the night before, had

47. Kyle to McKinley, June 24, 1901, William M. Stewart Papers, Nevada Historical Society.

48. Stewart to Kyle, June 28, 1901; Stewart to Binger Hermann, June 28, 1901; Hermann to Kyle, June 29, 1901; Hermann to Stewart, July 1, 1901; Long to Stewart (telegram), July 3, 1901; Kyle to Stewart (telegram), July 3, 1901; Kyle to Stewart, July 6, 1901. All of the above correspondence is in the Stewart Papers.

49. Questionnaire of October 17, 1907, Long Pension Application File; Information File, Nevada Historical Society; *Elko Free Press*, December 17, 1907.

50. *Nevada State Herald* (Wells), December 18, 1907; *First Biennial Report of the Nevada Historical Society, 1907–1908* (Carson City: State Printing Office, 1909), 21–22.

not left for his office. She sent her nephew, Dr. Henley Miller, to awaken him. The doctor knocked on Long's door, entered upon hearing no response, and found Long "lying on his side as if peacefully sleeping." The coroner was notified, and he concluded that Long, age 65, had died probably of heart trouble. The body of the "well known citizen" was taken to undertaker's parlors in Reno and prepared for burial. The coroner stated that an inquest was unnecessary.[51]

Obituaries lauded his Civil War record; it is doubtful whether Long told his Nevada associates of his unhappy postwar years in the army. According to one newspaper, he would "be missed by a multitude of friends, as all who knew Major Long knew him as a true and loyal friend."[52]

On December 13, services were held at the undertaker's. The pallbearers – three men from the surveyor general's office and three GAR comrades – transported the old soldier's remains to the GAR cemetery (then a portion of Hillside Cemetery). "Many sorrowing friends" attended the burial.[53]

In Nevada, Walter Sully Long employed his professional skills usefully. He held positions of public trust, participated in the social and cultural affairs of the communities in which he resided, and achieved a measure of acceptance and respectability. In various ways he aided in the growth and development of his adopted state.

Yet there was little in his career in or out of Nevada that would cause later generations to

51. *Elko Free Press*, December 13, 1907.

52. Ibid.

53. *Nevada State Journal*, December 11, 1907; *Reno Evening Gazette*, December 13, 1907.

remember him. Long himself would perhaps find it ironic that the sketches made in Eureka County and the Tempiute vicinity would bring attention to his life and work many years after his passing. To him, no doubt, the sketches were little more than a means of whiling away leisure hours or impressing a woman whose heart and hand he never won. He probably entertained no thoughts that posterity would see the sketches as engaging depictions of a part of the mining West's history.

Nevertheless, the rediscovery and reproduction of the sketches shed light on a time and place which have been more or less overlooked. Thanks to Long we have better knowledge of mining and human activity in Eureka and Lincoln counties, Nevada, in the later nineteenth century; and if he went to his grave believing that he left nothing of historical significance, his artistic endeavors of 1878-1880 prove otherwise.

Sketches in Silverland

JAMES C. McCORMICK

The watercolors of Walter S. Long were a source of puzzlement to researchers when they arrived on the University of Nevada campus in 1970.

Los Angeles book dealer Virginia Burgman, in a note to Special Collections librarian Robert Armstrong, had characterized the postcard-sized paintings as "original sketches" and went on to state that "besides being historical they are very good art work in that primitive style of early America."[1] Burgman was acting at the time as an agent for Dan Moore of the Family Book Shop in Glendale, California. Moore, the legal owner of the books, relinquished all publishing rights to the Long material in a handwritten note in April of 1970.[2]

Very little information regarding Walter Long accompanied the three sketchbooks and eleven separate watercolors at the time of their purchase. It was apparent from an inscription on a hand-drawn map in the first sketchbook that Long had been a civil engineer serving as U.S. Deputy Surveyor in Tempiute, Nevada. In another piece of correspondence to Armstrong, Burgman revealed that she had been "looking up something and ran across Walter S.

1. Note on invoice form from Virginia Burgman to University of Nevada Special Collections librarian Robert Armstrong, March 30, 1970. Special Collections Department, University of Nevada, Reno, Library.
2. Letter from Dan Moore relinquishing all publishing rights to purchaser of the Walter S. Long sketches, April 16, 1970. Special Collections Department, University of Nevada, Reno, Library.

Long" in the index to the 128-volume *War of the Rebellion: A Compilation of the Official Records of the Union and Confederate Armies*. She provided a citation for maps that Long had drawn during the Civil War, but at that point her interest was more commercial than scholarly. She was offering the books for sale and was curious to know whether the university might be interested in purchasing them.[3]

A decade later, an item on the agenda of a meeting of the University of Nevada Press Advisory Board seemed to represent an attempt to revive interest in the Long material. A single-page prospectus carried the heading "Watercolors of Nevada," and the board was informed of the range of subjects Long had covered in his small paintings – "mines, buildings, joss houses, interiors of miner's cabins, and scenery in eastern Nevada, in areas where photography was not yet being done."[4]

During the next ten years, additional research by the authors of this book and others led to the accumulation of a great deal more information about Long. Records concerning his career during the Civil War, his activities as a civil engineer, and his life as an appointed and elected public official were gathered from newspapers and government records from Nevada to Washington, D.C.

While Long's professional life has been recounted in fair detail, no additional material has been discovered regarding his interest in the visual arts. The three sketchbooks executed in

3. Letter from Virginia Burgman to Robert Armstrong, May 14, 1970. Special Collections Department, University of Nevada, Reno, Library.
4. Item VIII E on the agenda of a 1981 meeting of the Advisory Board of the University of Nevada Press. University Archives, University of Nevada, Reno, Library.

Nevada comprise his only known pictorial output. Searches through public collections in the state have turned up no additional paintings or other examples of graphic expression. References to Long in the newspapers of Eureka and Elko during his lifetime provide no clues to his interest in painting, nor does his detailed obituary which appeared in several newspapers around Nevada. And to date, no authenticated portrait of Long, photographic or otherwise, has been located.

It is difficult to assert that the outpouring of small watercolor paintings depicting the Eureka and Tempiute mining districts was Walter Long's only artistic venture. There is sufficient skill in his treatment of light and shadow on buildings and rock outcroppings and in his depiction of deep desert space to suggest prior experience in painting, if not some formal training. That he ended all expressive activities after completing the sketchbooks is also a questionable assumption. The authors await the discovery of additional paintings by Long, perhaps stored but forgotten in the dust of some attic, basement, or shed.

The outburst of painting activity that took place between 1878 and 1880 may have been Long's only sustained period of artistic work; it certainly demonstrates the importance of Elizabeth C. Parker in his life. It is not known whether the sketchbooks ever reached the woman who apparently inspired the elaborately decorated title pages. Miss Parker's full name appears only one time, on the title page of the first sketchbook (figure 16). While Long did not dedicate this book to Parker in so many words, it is difficult to refute the place of importance she held in the decision to create this and the other small books. Perhaps, to Long, the placement of the Parker House, Eureka's first hotel and two-story frame building (originally the Overland Stage Station in Austin, Nevada) near the center of a watercolor was intended as private amusement

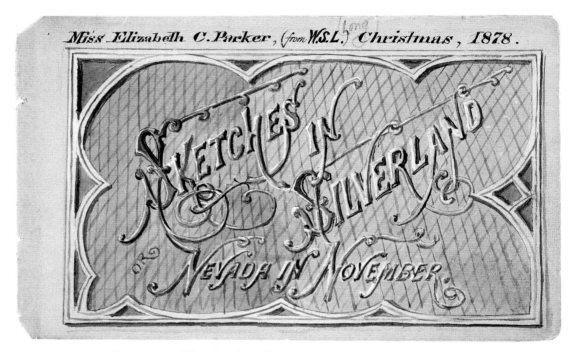

16. Sketches in Silverland, or Nevada in November. Christmas, 1878.

for Parker, a reference that she would be certain to catch when she examined the book (see figure 19, below). There is a dedication "to ECP" on the title page of the second sketchbook. This page, richly embellished with interlocking red lines against a blue and gray field, clearly features Miss Parker's initials in a crest at the top of the page, and directly below, another elaborate closure contains the initials "WSL." To strengthen the message, the artist added heart-shaped motifs in the upper corners of the design (figure 17). By the time Long got around to the third sketchbook, which he titled "In and Around Eureka, Nevada. May-June, 1880," there was no apparent reference to her on the title page. He did modestly pen his own initials inside a decorative loop in the lower right corner (figure 18).

However, an untitled poem was meticulously printed in the third sketchbook. It was written a few days short of the second anniversary of Long's arrival in Eureka.

> Imperfect; incomplete: but let it go
> "With all its imperfections on its head";
> Not what is done, but what I meant to do; –
> Beneath the signs the motive must be read,
> Fire, Flood, Disaster, – these may come to all,
> But Love and Constancy must ever live.
> Wherefore at *her* dear feet I now let fall,
> This Book, – unfinished; – *all I have to give.*
> *Eureka, October 23, 1880* *W.S.L.*

The last line of this poem conveys the depth of Long's emotions; it was written a full four months after the last watercolor in this book. His affection for Miss Parker appears to have

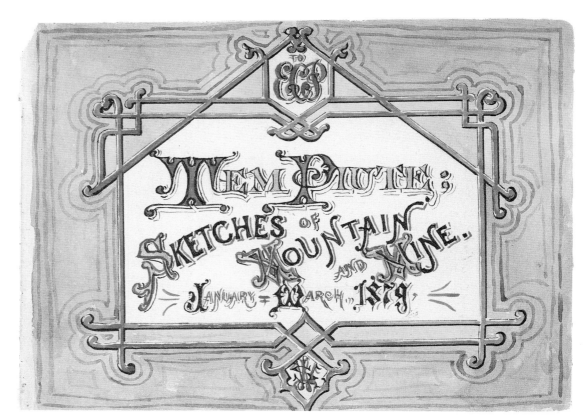

17. *Tem Piute; Sketches of Mountain and Mine. January—March, 1879.*

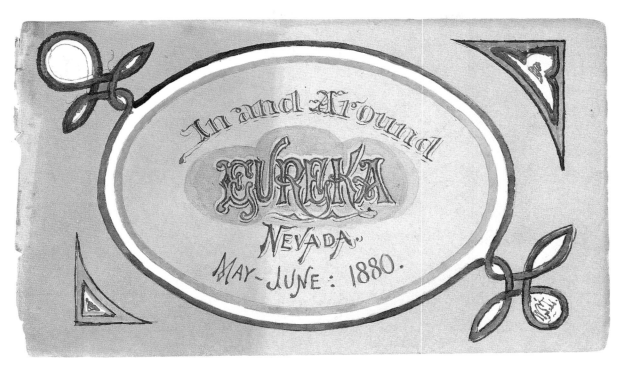

18. *In and Around Eureka, Nevada. May–June, 1880.*

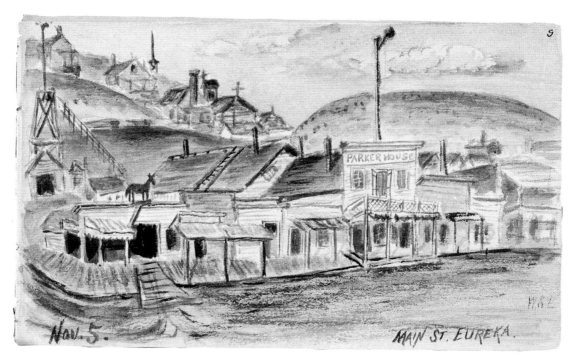

19. *Main Street, Eureka. November 5, 1878.*

remained steady; he poetically allows his sketchbook to "fall" at "her dear feet," and the suggestion that it is "all I have to give" possibly reflects the sparseness and loneliness of his life in central Nevada. Certainly, the watercolor paintings that will be examined on the following pages bear out this notion. There are seldom depictions of human beings, especially persons who might be colleagues of Long. On the other hand, it is possible that Long, more experienced in architectural and engineering matters, felt uncomfortable rendering animate forms and shied away from them.

The sketchbooks themselves were commercially made, with the words "Sketch Book" embossed in gold leaf on the covers of the first and second books and "Sketches" on the third. They were bound with a variety of colored papers, mostly hues of blue-gray and sandstone. Paper in all three sketchbooks bears the watermark "St Marcel-Les-Annonay." An oval blue label was affixed on the inside cover of each book, indicating that the books had been obtained from F. C. Hastings and Co., Drawing and Painting Materials, 54 Cornhill, Boston.

In all likelihood, Long purchased the books in Boston prior to his journey west with Dr. Stearns; and because of his familiarity with mapmaking, he probably exercised some care in their selection. Papers that are appropriate for drawing in pen and ink or pencil might not be suitable for an aqueous medium. It is also safe to speculate that he accumulated his paints, brushes, and other materials before arriving in Nevada, a region he could judge would offer limited quantities of art and drafting supplies. The materials that made up his painting field kit may have been in his possession for some time. Could it be that he took up the craft while living in Boston? Was it his plan to create watercolor sketchbooks as a pictorial diary of his new life in Nevada, and use them to continue the relationship with Miss Parker? In any event,

Long dated the inside cover of the first sketchbook in ink on October 21, 1878, eight days before his arrival in Eureka.

Each of the books is approximately 6 inches wide and 4 inches high. Long executed all but three of his paintings as horizontal compositions, a sensible approach considering the role of gravity when painting with watercolor. The artist relied on the flow of the medium down the paper to create passages of transparent color called washes. When an image was created with the spine of the book at the top, there would be a tendency for the cover and forward pages of the small book to flop over, disrupting the wet pigment. In the final analysis Long was a painter of landscapes, and the horizontal nature of the desert played an important role in the way he positioned his sketchbook.

In a rare moment, Long broke with the horizontal approach when he created a piece titled "Kinsey Mine, Down the Shaft" (figure 20). This vertical composition allowed a more complete depiction of the tall ladder and deep mine. The artist again employed this framing device in a painting titled "Interior of cave. First explored March 21, 1879" (figure 21). The previous day, Long and two companions, W. McMurray and C. C. Bradley, had entered a cave on the "South side of Tem Piute Mountain," and the artist rendered a study of its distant entrance (figure 22). The watercolor of the cave's interior represents one of Long's more ambitious undertakings; the careful exposition of the bulging rock walls and stalactites suggests that he may have stayed in the cave for some time, possibly working by the light of a lantern that is depicted in several views of his various offices.

Walter Long appears to have been a man of well-regulated habits. Part of this tendency may have been the result of his experience as a civil engineer. Long, as artist, followed a num-

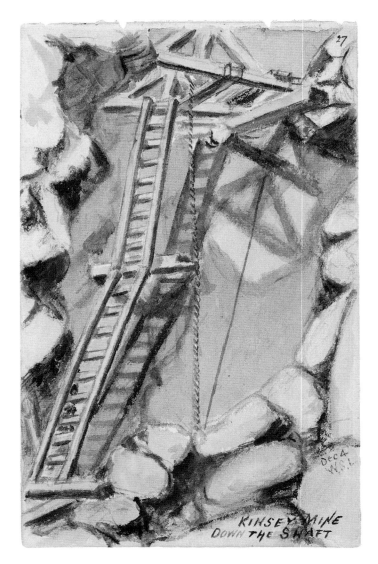

20. *Kinsey Mine, Down the Shaft. December 4, 1878.*

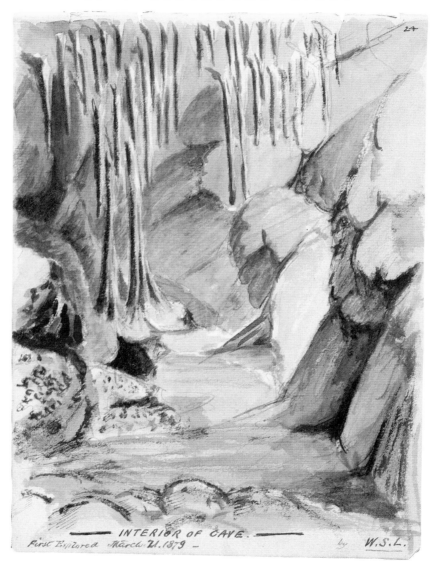

21. Interior of Cave. First Explored March 21, 1879.

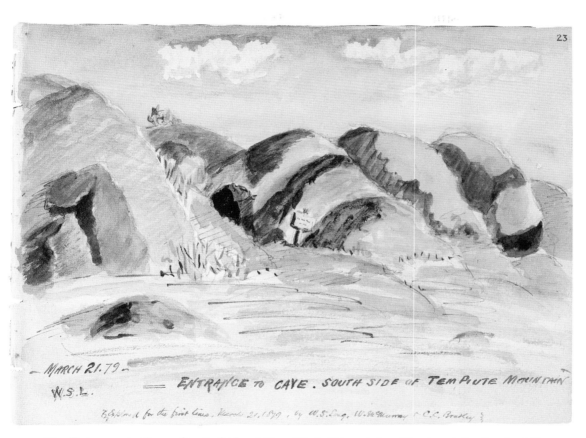

22. *Entrance to Cave, South Side of Tem Piute Mountain. (Explored for the first time, March 21, 1879, by W. S. Long, W. McMurray, & C. C. Bradley.) March 21, 1879.*

ber of practices throughout the preparation of 100 images (including title pages, maps, poems, and pencil drawings), conventions that proved helpful to the authors of this book in analyzing his style and development.

Long seldom completed a painting without dating it. In the first sketchbook, painted between October 29 and December 8, 1878, Long recorded the month and day on all but four of his works. He assigned only the year to entries for December 6 and December 8, a day when he completed two pictures. Two watercolors in this first book are undated, but Long rarely omitted this element in subsequent studies.

Long occasionally skipped a page as he drew and went back at a later time to fill the blank paper with a painting. The map of Southern Nevada on the first page of the first sketchbook was executed on December 1, 1878 (figure 2). The next three pages are dated October 29, 1878, the only time Long accomplished three paintings in one day. He made these watercolors in Palisade, Nevada, presumably on a layover between his arrival in Palisade on the Central Pacific Railroad and his departure for the town of Eureka, 85 miles south on the Eureka and Palisade Railroad. Long seemed to be unsure as he rendered the abruptly rising cliffs that define the narrow limits of the town. The artist appeared to be caught between striving for accuracy in his drawing and working in a difficult-to-manage fluid medium, and, as a result, he was unable to overcome some of the characteristics of "a genuine American primitive," the kind of artist the book dealer had referred to in her correspondence with Robert Armstrong.

There was a cadence to Long's painting during his first months in Nevada. Between November 5 and 15, only two days passed when he didn't make an entry in his sketchbook. Perhaps it was thoughts of Miss Parker that animated these early artistic efforts. It is known that

he explored Diamond Valley and Fish Creek in the southeast corner of Eureka County during his first week in Nevada, and he continued to produce a painting every day or so after arriving in Tempiute.

The artist prepared an "Index to Sketches" on the last page of the first sketchbook. Each of his paintings was documented in the index with a page number and title. The titles in the index did not always exactly match those he originally wrote on the painting. For instance, on page 33 of the first sketchbook, Long simply titled the painting "Foreman's Cabin" (figure 23). Yet his entry in the index reads "Foreman's Cabin & Indian Wicky-up." Similar variations can be observed with other paintings.

It is apparent that Long wrote page numbers on the individual watercolors after completing all of the images in the first two sketchbooks. The dates on the thirty-two drawings of the first book are not in chronological order, but Long's system of numbering the pages did not take this into account. (The pages of the third sketchbook were not numbered at all.)

There is a possibility that Long worked on other sketchbooks during this period. A year and two months elapsed between the completion of the second volume in March of 1879 and the beginning of the third on May 8, 1880. Several of the unbound watercolors carry dates from this interval and were painted on paper that is similar in size and color to that found in the three bound sketchbooks.

Walter Long signed his paintings in several ways. The most common was the inscription of the initials "W.S.L." in the lower right-hand corner of a painting. On occasions, his initials appear in the lower left. The viewer can sometimes find the signature element in an out-of-the-way place – as in a view of his office titled "Luxury" (figure 24). Long departed from the usual

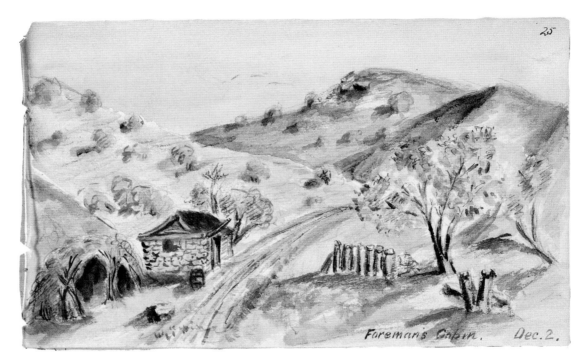

23. Foreman's Cabin. December 2, 1878.

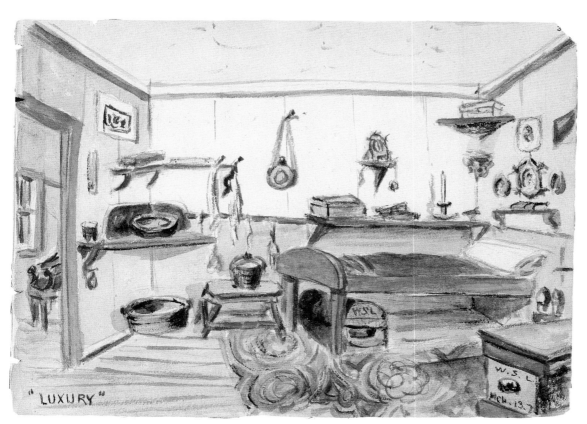

24. "Luxury." March 13, 1879.

procedure and signed the painting twice, on the end panels of two trunks sitting on the floor of his room. It is almost a certainty that "W.S.L." was actually painted on the end of the sturdy trunk (with strap and rounded lid) which moved with Long from one temporary residence to another.

Long again used the device of signing his work in a strategic location in a watercolor of the "new" Eureka County courthouse painted on May 8, 1880 (figure 25). Working in a manner similar to that of medieval masters who placed their monograms in building stones, tree trunks, and furniture. Long carefully recorded his initials on an elevated section of sidewalk in the lower right-hand corner and again, in a painting executed the following day, his slanted initials appear on the boardwalk in front of the Eureka House (figure 26), a rooming establishment where Long maintained an office.

Virtually every painting in the sketchbooks bore a title. The tenets of mapmaking seemed to apply in Long's artistic endeavors, cartography being a discipline in which distinctive locales and features are concisely labeled.

Long sometimes assigned titles that indicate the site being depicted as well as appropriate family names, as in "Horton's at Quinn Cañon." And he occasionally recorded his point of view in a painting, as in "Tempiute Canon Looking East" and "Diamond Valley from the Kit Carson Mine."

While most of Long's titles were descriptive, he occasionally employed ones that were more evocative of his current condition or mood. He was obviously pleased with his new quarters in "Beginnings of Comfort" (figure 27) and "The March of Improvement" (figure 28). "Luxury" expresses a similar sentiment (figure 24).

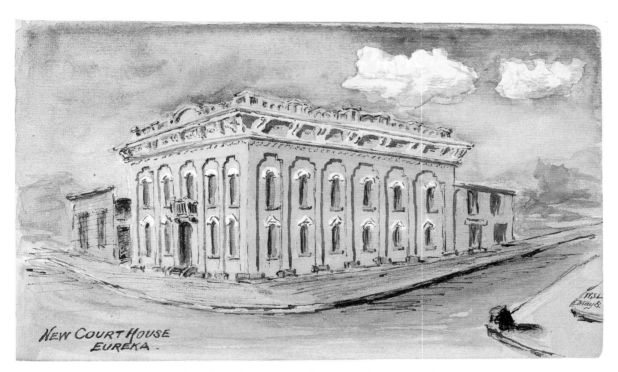

25. *New Courthouse, Eureka. May 8, 1880.*

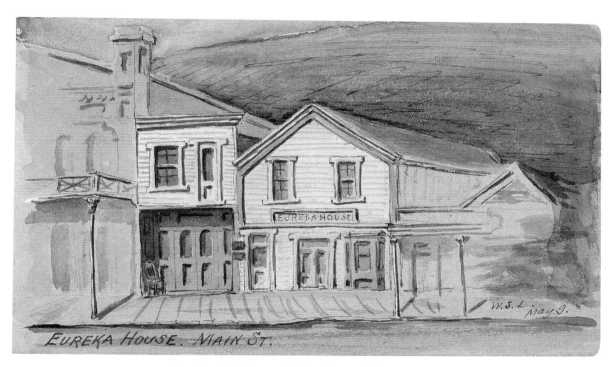

26. *Eureka House, Main Street. May 9, 1880.*

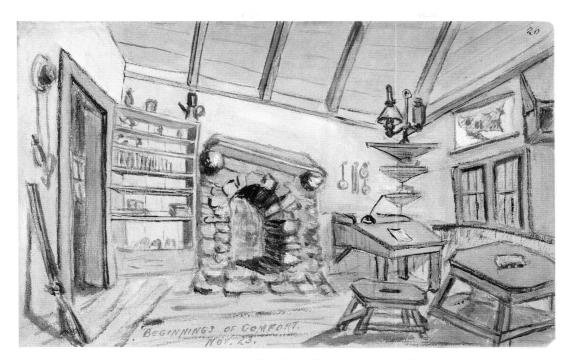

27. *Beginnings of Comfort. November 23, 1878.*

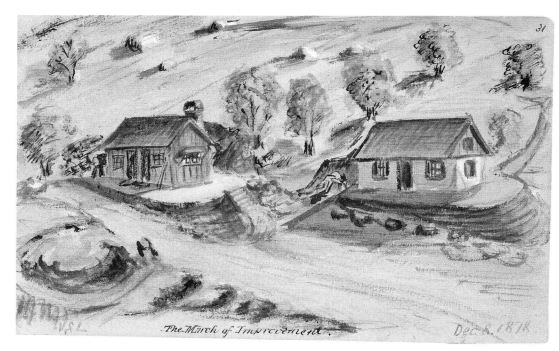

The March of Improvement.

28. *The March of Improvement. December 8, 1878.*

It would be helpful to any person studying the paintings of Walter Long to examine them with a magnifying glass. His lettering skills were well honed by the time he arrived in Nevada and he was especially adept at writing in a minuscule text. In "Rattler Mine" (figure 29), Long virtually buried the word "Kinsey" in the hills in the upper right-hand corner. The artist also created subheadings for his titles with letters less than 1/16 inch high. "Buttes Station" (figure 30) contains such a label. The script in the secondary title, "White Pine Mts in distance," is small enough that it is difficult to read with the naked eye.

If it were possible to return to a site in the central Nevada desert on an afternoon in 1879 when Walter Long was engaged in painting a small watercolor – what could be observed?

In all likelihood, this man of slight stature in his late thirties would be seated on a boulder or wagon seat, or crate if he were in the neighborhood of a ranch or mine. There is no evidence that Long carried a fold-up stool; at least the views of his several offices do not show such an item among his equipment.

Long and his companions may have traveled to their work on horseback, but his painting implements would have added little weight to his professional gear: a brush or two, several pencils and a knife, an eraser, a canteen for water, a smooth piece of metal for mixing paint, and a sketchbook. All of these items could have been carried in a fabric bag, or they may have been stashed in a wooden box along with surveying equipment, all possibly purchased from the same Boston store where the artist obtained his sketchbooks. Long, a meticulous man by trade and inclination, could have quickly assembled his out-of-doors studio and been sketching in a matter of moments.

The colors that Long employed probably did not come from paint tubes. Rather, as with children's watercolor sets today, he dipped his brush into pads of solid pigment (a combination

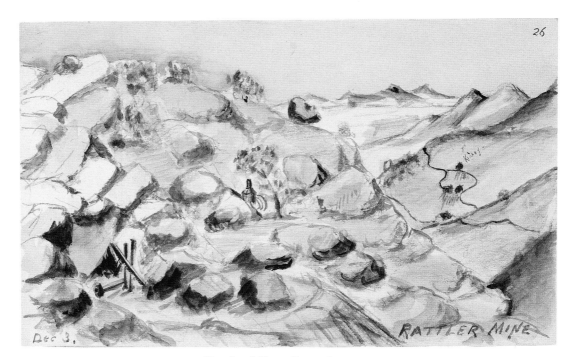

29. *Rattler Mine. December 3, 1878.*

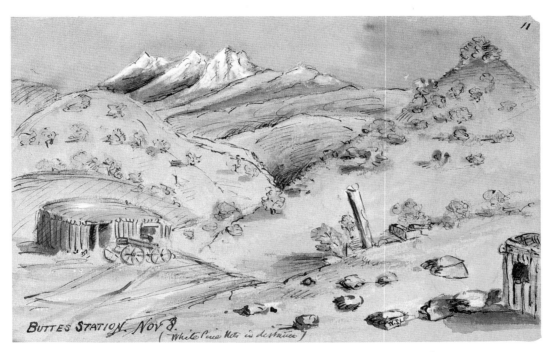

30. Buttes Station (White Pine Mountains in Distance). November 8, 1878.

of dry color and some form of natural gum), activating the colors with water from his canteen. The longer and more vigorously he rubbed the wet brush on the pad, the more intense the color that could be applied to the paper. Long's selection of colors could best be described as limited; his palette probably numbered no more than ten hues. It was his skill in mixing that provided the appearance of a wider spectrum.

A careful examination of Long's first sketchbook reveals his method of composing his paintings. Initially, he would lightly sketch the essential features of the terrain with a graphite pencil. On rare occasions he employed a fine pen point and ink. He would establish the horizon line, usually a sawtooth configuration that echoed the hills or range before him, and print the title and date of the picture.

Once the scene had been roughed in, the artist would begin applying color. The authors believe that Long sometimes worked on the details of the middle distance before laying in the sky, an approach contrary to the one employed by most watercolorists. His attraction to architecture and rather meager treatment of the sky, especially in the early paintings, helps to reinforce this opinion.

When did Long paint? Mornings? Afternoons? If one uses the earliest paintings in the first sketchbook as a guide, the viewer might conclude that Long worked around midday with the sun high in the sky. There are few decisively cast shadows in these works. It is more likely that in the beginning Long steered clear of shadows and spent his time laboring to accurately depict the buildings and sage before him. With time, though, Long gained confidence and skill when dealing with light and shade and began to take shadows into account as he worked.

"Entering the Desert" (figure 31) is a fascinating study. Could it be that the figure in the

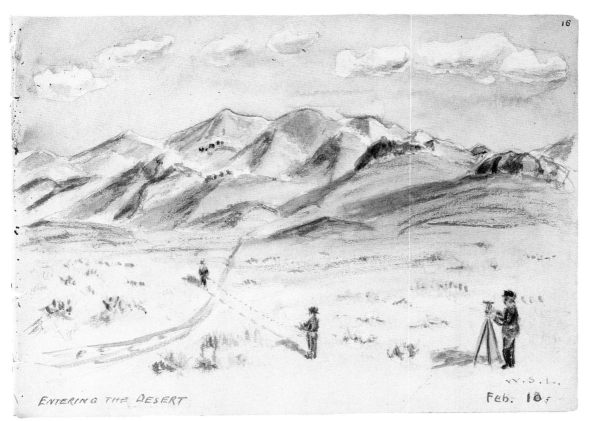

31. Entering the Desert. February 10, 1879.

foreground is a self-portrait? Is the surveyor clad in a blue coat and sporting high boots wearing the remnants of a military uniform? Are these the same boots and coat that appear in a painting titled "My Den" (figure 32)? An exact comparison is difficult because the garments were rendered in a relatively sketchy manner in both studies. Speculation aside, the three men in the painting were conducting a survey, the two in the middle distance each held the end of a standard 66-foot surveyor's chain. Long recorded the scene with the low sun throwing distinct shadows across the desert floor. In another painting, "The Mitten Mountain" (figure 33), the surveyor is absent from the scene but his presence is felt; a transit standing in the foreground, and the stadia rod lying on the ground suggest that the artist would return to his work as soon as the small painting was completed.

An examination of the Long sketchbooks suggests that the artist was fascinated with a variety of subjects. Only a handful of the images deal solely with desert terrain, and like most artists Long seemed interested in the shape of things. Thus when working on a landscape he often chose to depict vistas that contained unusual geologic formations. "Profile Rock near Head Mine" (figure 34), a painting created in the midst of a dramatic arrangement of boulders, calls the viewer's attention to the imagined profile of a head facing the sun at a near 45-degree angle. In "The Mitten Mountain," Long emphasized a curious glove-shaped outcropping in the distance.

The artist seemed compelled to include some trace of human activity in most of his studies. Often he would place an object such as a barrel or fencepost in the foreground, an approach that not only presented what Long was observing at the time but also worked as a

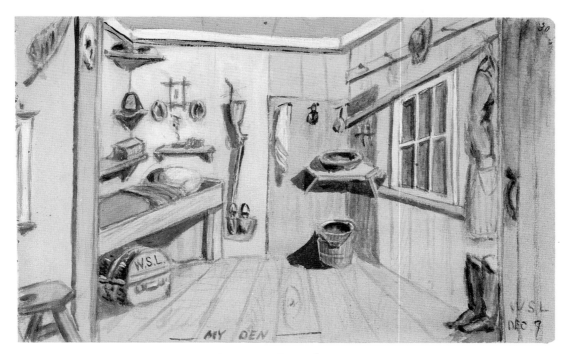

32. My Den. December 7, 1878.

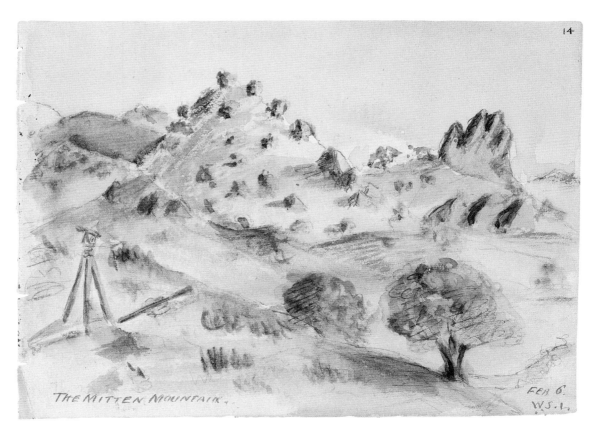

THE MITTEN MOUNTAIN.

14

FEB 6.
W.S.1.

33. The Mitten Mountain. February 6, 1879.

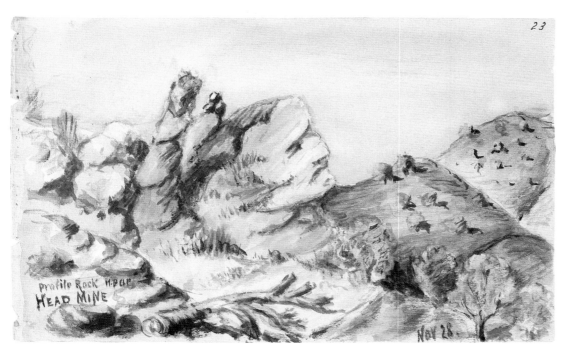

34. Profile Rock near Head Mine. November 28, 1878.

compositional element that strengthened the unity of the picture. In "China-Town" (figure 35) the cluster of buildings and trees that made up the small community was framed by the clothes-lines in the lower right, the clouds in the sky, and the triangular patch of ground on the left. These features form closures that help to direct the viewer's attention toward the houses that initially captured the artist's eye.

For the most part, Long was attracted by man-made structures. Whether it was the fa-çades of businesses on Eureka's Main Street or shacks at isolated ranches or mining opera-tions, the artist accepted the challenge of dealing with architectural subjects and he rendered surfaces of wood, stucco, and stone with more than casual attention.

Long's treatment of conventional perspective was uneven. By the time he painted Eu-reka's brick and stone "Public School" and the "Catholic Church" next door on June 2, 1880, he had become adept at two-point perspective (figure 36). Considering that this painting was a freehand exercise, Long held to a relatively consistent set of vanishing points and he height-ened the sense of depth by softening the left-hand side of the school building, which, in the process, helped to advance the white picket fence in the foreground. On the other hand, Long occasionally lapsed into awkward methods when dealing with perspective. In "Eureka House, Main St." (figure 26) he drew the front of the four businesses as if he were standing directly before them. However, the boardwalk tilts down as though it had been viewed from another, higher location, and the boards recede toward a vanishing point that is not consistent with the sides of the buildings.

The interiors of various offices and cabins were some of the most complex studies under-

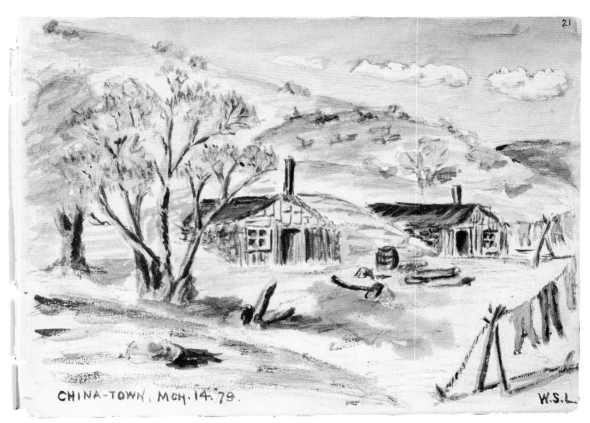

35. China-Town. March 14, 1879.

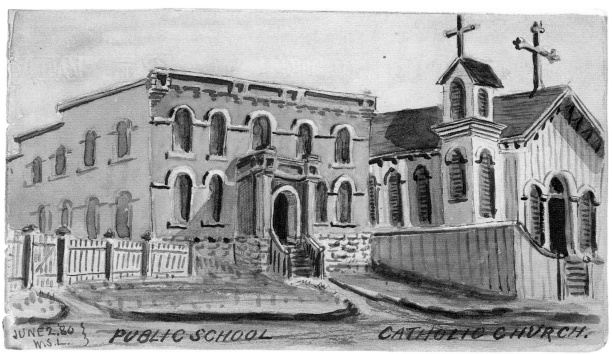

36. *Public School, Catholic Church. June 2, 1880.*

taken by Long during the years he worked on the sketchbooks. Of the fourteen paintings that qualify as interiors, nine are representations of Long's own rooms, both offices and living quarters. The artist seemed to falter when he painted a room with a lean-to ceiling. In "Beginnings of Comfort" (figure 27) he lost track of the vanishing points and, as a result, the various tables and fireplace hearth appear to exist on different planes.

It is obvious the artist preferred quarters in which his bedroom was separate from the studio where he conducted business. And Long, with characteristic attention to detail, provided a graphic inventory of the tools, furniture, books, scrolls, and other possessions that moved with him across Nevada.

Long's double-barreled shotgun appears in four of the paintings. In the earliest depiction, the gun stands against the wall by the door of his new office (figure 27). Two weeks later, it was placed within arm's length of his built-in bed and hung upside-down by a strap (figure 32). Another watercolor of the room (figure 37) reveals the interior from a slightly different angle. This time, the gun was positioned over a flame-filled fireplace; it rested on what appears to be two hand-carved wood forks. On April 13, 1879, Long again celebrated his arrival in new quarters with an entry in his sketchbook. The gun, barrels partially hidden behind the door, had been placed directly over his narrow bed (figure 38). There is no evidence in the sketchbooks that Long took his shotgun along on his surveying projects, but it was always near at hand in his quarters.

Walter Long looked with an acute eye at certain places in the desert and the towns where he lived, and on some days his work was better and more perceptive than on others. Perhaps

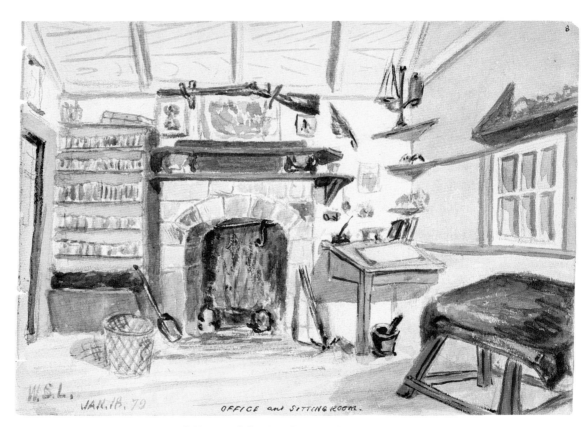

37. Office and Sitting Room. January 18, 1879.

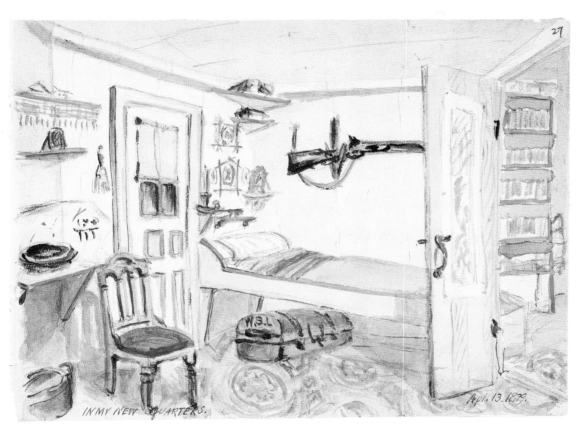

38. In My New Quarters. April 13, 1879.

the following comments will help to illuminate the artist's technique and his point of view as well as describe the scenes he was painting.

Palisade, Nevada, October 1878

Palisade, Nevada, offered Long his first opportunity to work in one of the new sketchbooks.

The township had been established in 1870 as a rail center for the Central Pacific Railroad and became the northern terminus for the narrow-gauge Eureka and Palisade Railroad three years prior to Long's arrival late in 1878. Palisade was to be plagued with a fire that gutted most of the north end of town just after the turn of the century, and a flood in 1910 washed away many structures, several bridges, and miles of Eureka and Palisade track along the Humboldt River.

Long's paintings of the town reveal a more placid time. On October 29, he took advantage of the layover on his journey to Eureka to paint three watercolors depicting Palisade and its surroundings (figures 39, 40, and 41).

The artist, attracted to the sharply rising columns of Palisade Canyon, initially established the terrain and buildings of the town in pencil. These sketchy lines served as a framework for his rather halting application of paint. His treatment of the structures in the railroad yard seem unsure, typical of someone who has not worked with a brush for some time. In the last painting of the day, a study of two distant railroad trestles, Long employed touches of opaque white paint in the sage on the hillside and on the wooden beams of the bridges, a method he would use often to strengthen the details in his paintings.

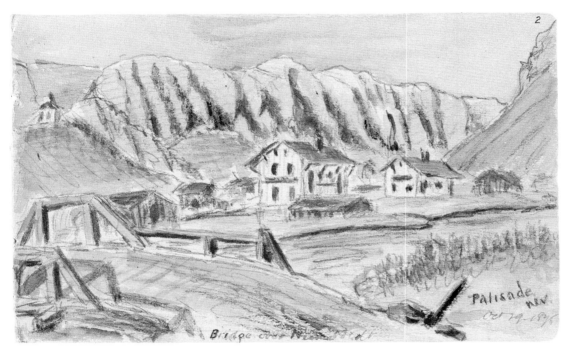

39. *Bridge over Humboldt, Palisade. October 29, 1878.*

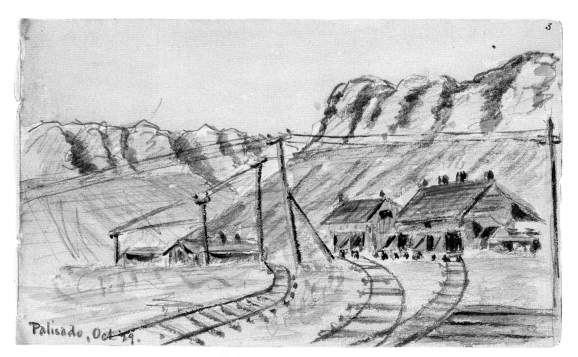

40. Palisade. October 29, 1878.

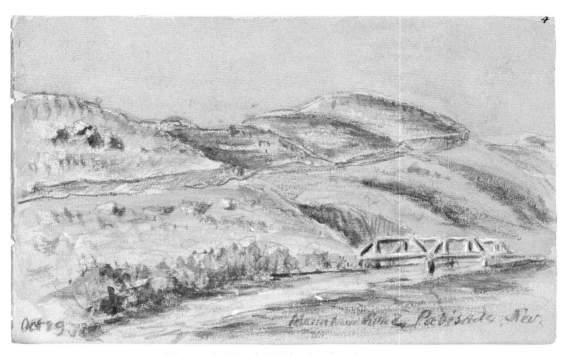

41. Mountain Road, Palisade. October 29, 1878.

Eureka, Nevada, November 1878

Walter Long executed two views of downtown Eureka during his first week in Nevada.

The initial watercolor, dated November 3, was a study that Long titled "'The East End,' Eureka" (figure 42), a depiction of a group of storefronts along Buel Street. The Opera House on the left should not be confused with the Eureka Opera House that still stands at the south end of Main Street. The size of the older structure, as painted by Long, does not appear sufficient to match the boast that it was the "Largest Hall in Eureka" with a seating capacity of five hundred people.[5] This building had been erected in 1874 and bore the name of Bigelow House for several years. It was destroyed by a fire that swept through the east side of Eureka some five years after Long completed his painting.[6] The artist offered a study of Eureka that is rich in architectural detail; the posts, boards, and roof lines of the houses on Buel and Spring streets were recorded with painstaking care.

Two days later, Long stationed himself on the east side of Main Street, possibly on the boardwalk at the corner of Main and Bateman streets. Or could it be that he sat near the window of his own room in the Jackson Hotel? It is difficult to determine just exactly where Long was painting, given his awkward handling of perspective. Both the window and street levels seem plausible depending on which of the vanishing points the viewer accepts. Either

5. Advertisement that appeared regularly in the *Eureka Sentinel* during 1879.
6. Phillip I. Earl, *Eureka's Yesterdays: A Guide to an Historic Central Nevada Town* (Reno: Nevada Historical Society, 1988), p. 25.

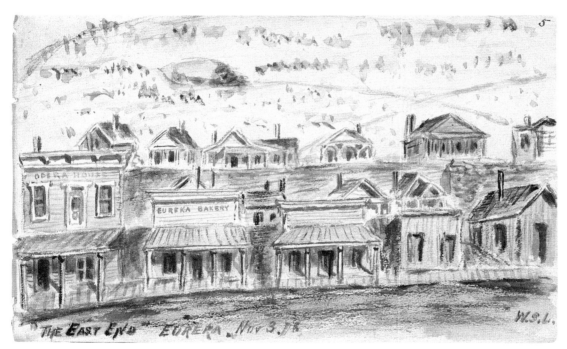

42. *"The East End," Eureka. November 3, 1878.*

would have provided a sweeping view of the tightly packed row of buildings across the way. With all the wood façades before the artist, he chose to paint a name on only one business – the Parker House (figure 19).

The Parker House advertised that "The appointments of this hotel are first-class, the rooms having been enlarged and elegantly furnished." A further amenity was described; "Attached to the premises is a first-class restaurant" which provided board at $8.00 per week and single meals for fifty cents.[7] It is difficult to tell from Long's painting whether the Parker House extended to a second structure located directly behind.

Long's own accommodations in the Jackson Hotel possibly afforded a view of the new Eureka County courthouse that was under construction during his first stay. This impressive structure was nearing completion when he painted it on May 8, 1880 (figure 25). The courthouse was to play a significant role in Long's life; the *Eureka Sentinel* noted on June 30 that he had filed there as a candidate for county surveyor in the November election.[8]

While street maps that reconstruct Eureka's business district during the late 1870s are relatively thorough, the establishment down the street from the Parker House on the southwest corner of Main and Bateman streets is not recorded; it was probably a commercial stable. The ramp that interrupts the boardwalk undoubtedly allowed horses to pass into the shelter. While Long did not paint the name of the stable on the building, he did capture a curious form of advertisement – a life-size replica of a horse standing on the roof of the stable. In the dis-

7. Advertisement that appeared regularly in the *Eureka Sentinel* during 1879.
8. *Eureka Sentinel*, June 30, 1880.

tance, Long suggested a number of private and public buildings; the cross that rises above "Nob Hill" is possibly the first Catholic church in Eureka, St. Brendan's.

"Wickyup," Tempiute, Nevada, November 1878

Walter Long arrived in Tempiute in early November, acquired a cabin, and settled in, evidently intending to search for "valuable mining property in Tem Pahute District."[9]

A watercolor painting on November 14 titled "Our Present Habitation, Tempiute" (figure 43) depicts a stone cabin nestled on a small ledge surrounded by large boulders. Long's rather sketchy rendering leaves the exact relationship of the single-room house to the steep bank directly behind it in doubt. Typical of other cabins in the region that Long painted, the back of the structure was probably excavated out of the side of the hill. The artist had to endure the chilling effects of fall temperatures as he painted; inside, a fire in the stove pushed smoke up and out the stovepipe on the roof. An axe leaning against the side of the cabin had been used to cut the wood in the carefully stacked pile nearby.

Long provided an alternate title to this painting in the index of the first sketchbook: "First House at Tempiute – New Captain's Quarters." But it is the title on the actual painting that is more instructive. Who was the companion who prompted Long to refer to "*Our* Present Habitation"? If the *Eureka Sentinel*, which announced Long's arrival on October 31, had reported

9. Ibid., October 31, 1878.

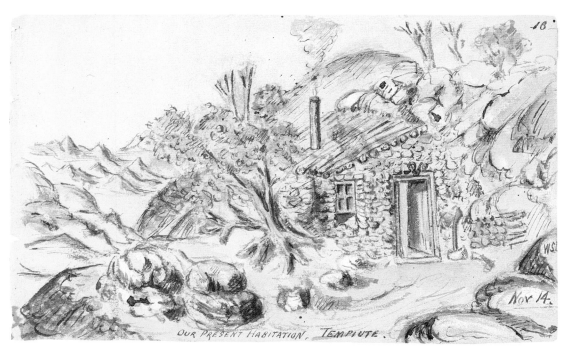

43. *Our Present Habitation, Tempiute. November 14, 1878.*

their intentions accurately, it is possibly Dr. Stearns, his traveling companion from Boston, who lived with Long during his early days in Tempiute.[10]

The next day, November 15, Long executed one of his most fascinating images, "Interior of 'Wickyup'," a closer view of the same dug-out cabin, this time with a section of the front wall cut away (figure 44). This pictorial device, a common practice among engineers, allowed for a graphic exposition of the cabin's interior, the rough-hewn walls and tall posts that held up the single-pitch roof. Boards had been laid on the dirt floor and a top-loading stove placed on them. Near the door, an enigmatic form dominates the room. Is it a blanket intended to divide the single room into two areas? Or could it be that the person who built the cabin left a topped tree inside? Typical of Long, everything in the cabin was in its place; nails had been driven into the walls and floor-to-ceiling posts, and these served as hangers for a canteen, towel, ladle, and watch, on which Long carefully noted the time at ten minutes to two. Long's boots had been positioned on the floor beside the bed, and his pants, coat, and hat had been hung nearby.

The presence of Long's companion is indicated by a second shotgun leaning side by side with his own piece on the back wall and by two broad-brimmed hats hanging across the room from each other. Under the bed was a valise that does not appear in any of Long's other views of his bedrooms or offices.

It is apparent that Long wanted Miss Parker to get a vivid picture of his life in Nevada; he did not romanticize his situation in paintings such as "Interior of 'Wickyup'." If there were

10. Ibid.

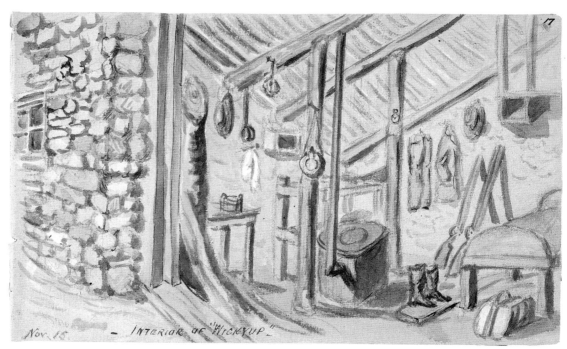

44. *Interior of "Wickyup." November 15, 1878.*

ever plans for Miss Parker to join him in Nevada, the artist did not seem concerned that such mundane subjects might dissuade a lady from abandoning the relative comforts of the East Coast.

Cabins and Ranches, 1878–1879

Walter Long's travels throughout central Nevada were not consumed entirely by his surveying trade. It is apparent that there was often sufficient time to pull off the trail and document an isolated cabin or ranch. And there is little evidence in these paintings that Long had much association with their inhabitants. Pictorially, he seemed more attracted to the wagons and other pieces of equipment in the yards and along the roadsides (figures 45 and 46).

The painting of December 6, 1878, is a rarity; it was a day when the artist found time to render four separate cabins on one page (figure 47). He evenly quartered the small sheet in the sketchbook in pen and ink and printed the title, "Miners' Cabins," at the center. Long concentrated on the details of the structures themselves; minute features such as stovepipes, lintels over doorways, and the construction of the various cabin walls were rendered with characteristic precision. By comparison, the treatment of the surrounding terrain was more suggestive. The landscapes in these four studies are almost lyrical; the hills twist and curve around the cabins, trees and shrubs are established with a modicum of brushwork.

The exterior of McCutcheon's Ranch at Cottonwood Creek was the subject of a Long painting on February 3, 1879 (figure 48). The sparseness of the surrounding area was heightened by the artist's careful delineation of the buckboard and rigging that had been left in front of the wood cabin. The following day, Long turned his attention to the interior of this structure

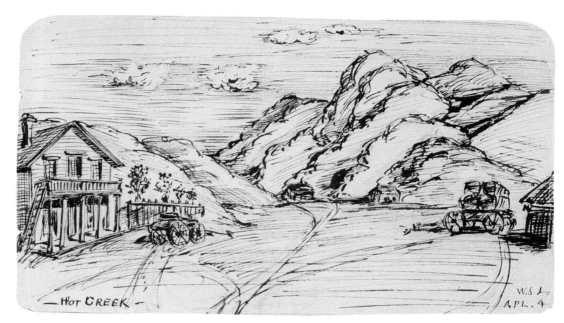

45. Hot Creek. April 4, 1879.

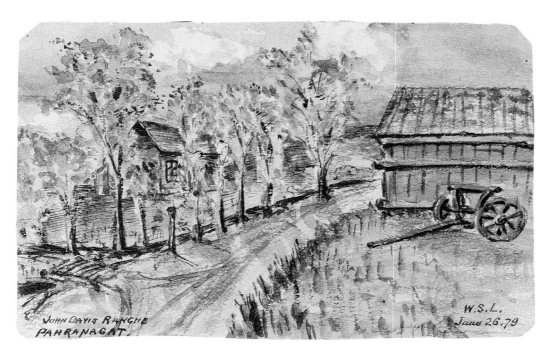

46. *John Davis Ranch, Pahranagat. June 26, 1879.*

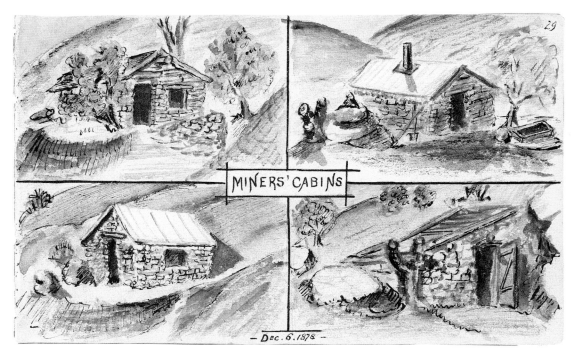

47. *Miners' Cabins. December 6, 1878.*

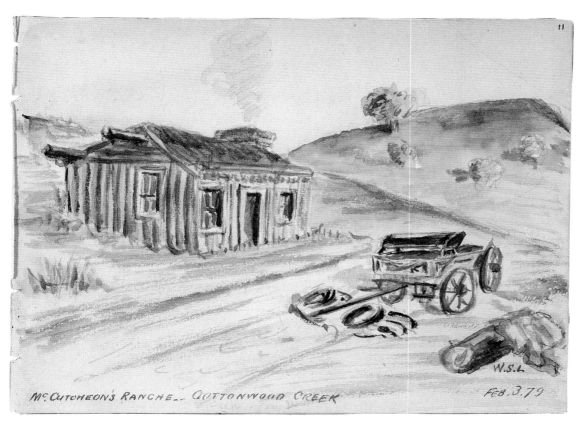

48. McCutcheon's Ranch, Cottonwood Creek. February 3, 1879.

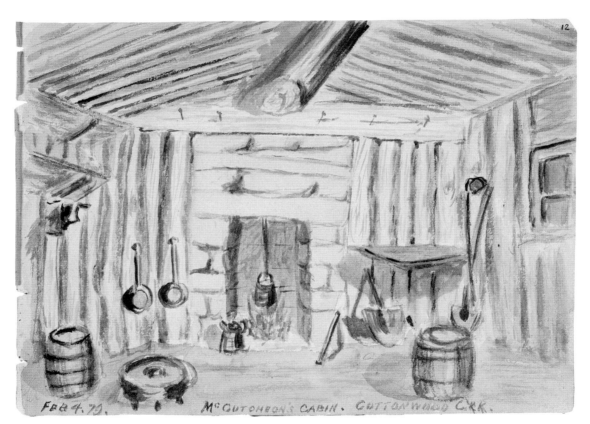

49. *McCutcheon's Cabin, Cottonwood Creek. February 4, 1879.*

(figure 49). The picture suggests an austere life; the room contains only objects of utility —
barrels, shovels, pot and pans, and a saw. Nothing decorative or sentimental here. Except for
the warming flames in the fireplace, it is almost as if the viewer were looking into a static pe-
riod room in a museum.

Wyandotte Mine, November 1878

"Open Cut, Wyandotte Mine" (figure 50) was painted from a unique viewpoint. Long appears
to have stationed himself above ground level where two miners were high grading. The man in
the distance shovels ore into a wheelbarrow and rolls it down the slope to the pile in the fore-
ground from which the second miner picks out chunks of rock. The artist captured the miner
cobbing the ore with a hammer, breaking up the hard rocks and selecting pieces to be hauled
away in the sacks that were lined up beside him. This is one of Long's most candid studies. In
the manner of traditional genre painting, he shows the two miners going about their solitary
tasks, unaffected by the artist or other goings on.

Coal Burners' Camps, 1878–1879

In the *Nevada Adventure*, James W. Hulse discusses the role of the charcoal burners in the
mining industry of the 1870s. "Because the ores of Eureka had to be smelted in furnaces at
extremely high temperatures, charcoal was in great demand. Hundreds of men made their
living in the mountains around the town by gathering wood from the pine and juniper trees

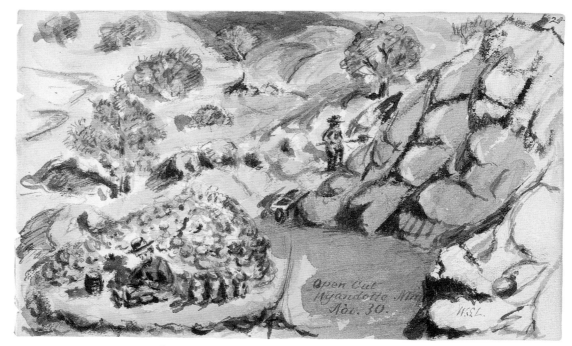

50. Open Cut, Wyandotte Mine. November 30, 1878.

and carrying it to special outdoor ovens where it was transformed to charcoal for the furnaces in Eureka."[11]

The itinerant nature of the coal burner's life was captured by Long on November 2, 1879 (figure 51). A simple camp had been set up in a small clump of trees; Long's presence seems to have coincided with the preparation of a meal, the campfire warms the contents of a frying pan and coffee pot, and plates and utensils, neatly arranged on a wooden box that had been converted into a low-lying table, await a couple of diners.

Long had happened across another camp (figure 52) on December 5, 1878. The "carbonari" who worked at this site were not depicted. It is impossible to tell whether their absence in the painting was by choice (the burners' or Long's), or because the camp was unoccupied when he arrived. In any case, Long treated the scene as if he were illustrating an encyclopedia, the tools and raw materials of the trade laid out in much the way an artist sets up a still life in his studio.

Against the backdrop of a nearly denuded terrain, Long painted the cone-shaped stack of wood, an oven that would be covered with mud and then given a final pack of dry earth before being ignited. The oven would burn for a number of days while the men set out to find additional wood for the next firing. Once the immediate area had been stripped of usable wood, the party of charcoal burners would move to another site.

The temporary nature of this camp is evident from the lean-to on the left. It was probably

11. James W. Hulse, *The Nevada Adventure* (Reno: University of Nevada Press, 1981), p. 142.

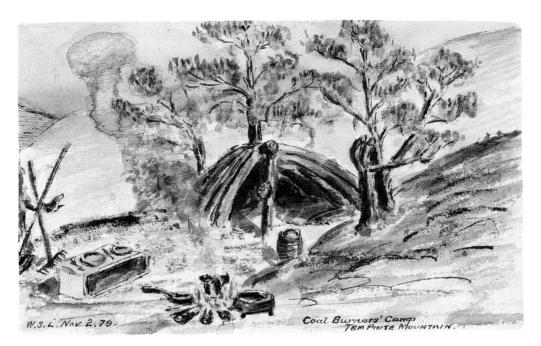

51. *Coal Burners' Camp, Tem Piute Mountain. November 2, 1879.*

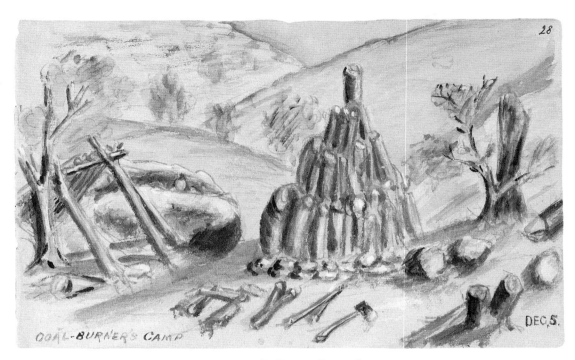

52. *Coal-Burner's Camp. December 5, 1878.*

made from wood gleaned from nearby stands, but it would offer little protection from the bitter cold of winter that lay just ahead. The funnel-shaped basket that lies next to the lean-to is an Indian burden basket.

New Quarters, April 1879

The last three watercolors in the second sketchbook represent the most thorough attempt by Long to document the appearance of his living quarters. It is not known exactly where the building in which he was living was located, but the presence of a dining room suggests that Long had settled into a boardinghouse or commercial hotel.

Working in a manner similar to that of a cinematographer, Long takes the viewer on a tour of his residence, beginning on April 10 with a painting of the dining room (figure 53). The lightly painted panels of the room contrast sharply with the bright blue and red trim around the windows and walls. The cloth-covered table had been prepared for four; a single wineglass and cruet-stand completed the setting. Long appears to have sketched this interior while sitting in the chair that normally occupied the place before the nearest table setting.

Three days later Long continued the series with a study titled "In My New Quarters" (figure 38), a warm and personal painting of his bedroom. The floor was partially covered with a richly patterned oriental rug and his trunk, as usual, was under the bed; shotgun, whisk broom, and basin were in place, and, typically, the artist's bed had been made, the blanket drawn tightly as if military regulations were in force.

At each new dwelling, Long reconstructed a symmetrical altar of photographs and other

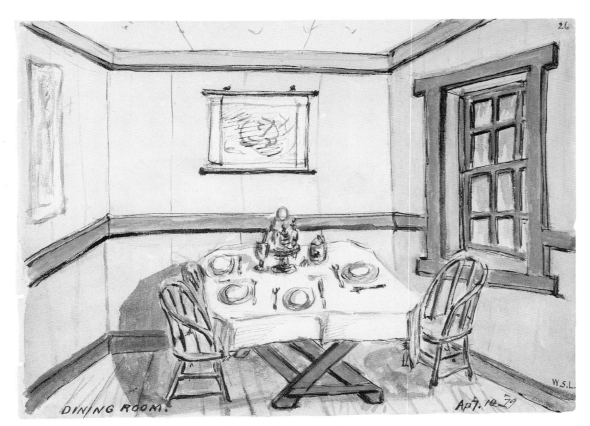

53. *Dining Room. April 10, 1879.*

memorabilia over his bed, this with the regularity of a man of the cloth. A small shelf that moved about with Long served to hold a variety of items: in one painting, a book; in another, a candle. The collection of photographs grew as time passed. In an interior view of December 7, 1878 (figure 32), Long hung a square photograph with an extended wooden frame as the centerpiece of his collection and it was flanked by two oval pictures that were similarly positioned in future depictions of his bedroom. In "In My New Quarters," Long added a new picture to his cluster of photographs. The elaborate frame looks as if it has a roof line, and contains what appears to be an oval photograph. In the spirit of pure speculation, one cannot help but wonder whether the subject of this picture was Miss Parker. Henceforth, the older, rectangular picture was placed above this newer one.

"In My New Quarters" provides an entree to the next painting (which is titled "Ready for Business"). The viewer is permitted to catch a glimpse of the next room; the tall bookcase which appeared in an earlier painting was filled with many volumes and a lantern was hung to the side of the case.

"Ready for Business" (figure 54), painted on April 14, serves as a graphic inventory of the artist's office. Long moved the side chair with the red velvet seat into the doorway, perhaps to hold the door open, and then proceeded to carefully document his well-organized studio. He gives us his drawing tables; the one on the left has a claim map of the Wyandotte silver mines on it and the other holds paper, pen, and inkwell. A T-square and several triangles hang on the wall between these tables. An object that was frequently affixed to the walls of Long's offices can be seen on the right near the ceiling. It seems to be the wing of a rather large bird.

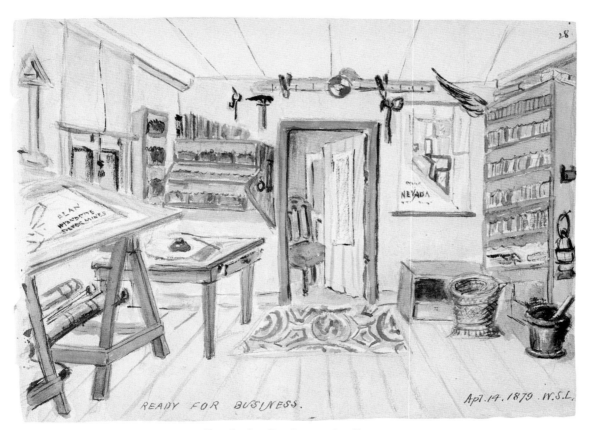

54. *Ready for Business. April 14, 1879.*

Beneath the wing is a map of Nevada with the county lines delineated in color. This and other maps owned by Long were mounted in the manner of Eastern scrolls with dowels affixed at either end that permitted them to be rolled up and safely transported.

There is a clarity and sureness in these three interiors that suggests not only an improvement in the artist's handling of the medium but also a heightened optimism about his life.

Louis Monaco and Walter Long, May–June 1880

Louis Monaco regularly advertised his business in the *Eureka Sentinel* during the 1870s and 1880s. Describing himself as "The Old Reliable Pioneer Photographer," Monaco boasted that, "Having the best arranged Gallery in the State, I am able to produce the truest and the MOST LIFELIKE PICTURES to be obtained in this State." It is apparent that Monaco, like many of his frontier counterparts, made a significant portion of his livelihood from portraiture and in this regard he offered his customers a wide range of specialties such as Crayon Finish Enlargements, Water Color, Porcelain, and Photo-chromo.[12]

In addition to this aspect of his trade, Monaco was called upon to document many of the mining operations in the region.

When Lambert Molinelli wrote *Eureka and Its Resources* in 1879 as a promotional piece to attract business interests to the county, he included not only Monaco's advertisement from the

12. Advertisement that appeared regularly in the *Eureka Sentinel* during 1879.

Sentinel, but also a number of wood engravings copied from Monaco's photographs of mills and furnaces in and about Eureka.

The relationship between Monaco and Walter Long, in addition to the likelihood that they knew each other, is apparent in several paintings that Long executed during May and June of 1880 and in photographs that Monaco took of mining facilities in the district during the same period. The chance that the two artists, one a photographer, and the other a watercolorist, selected the same locations to record their respective images is not farfetched; it is harder to accept the notion that they both included the same animate and transient forms in their pictures, unless, of course, they visited these locales at the same time. Long's painting of the "Eureka Consol. Furnaces" (figure 55), dated May 18, 1880, contains several similarities to a Monaco photograph of the same subject. While some details are left out of the Long watercolor for reasons of visual economy, the placement of a horse and wagon and the direction of the smoke pouring from the chimneys strongly suggests that Monaco's photograph was the source for Long's painting. Long's watercolor of the "Richmond Furnaces" (figure 56) provides even more telling evidence of Monaco's influence. There can be little doubt that Long copied the two men pulling a cart exactly as they appeared in the Monaco photograph. Finally, Monaco's view of the Eureka Consolidated and KK Hoisting Works at Ruby Hill preserved the appearance of several structures and two sets of converging narrow-gauge tracks that hauled ore to the smelter, a shortline system purchased by the Eureka and Palisade Railroad in 1875. While the point of view in these two scenes is the same, Long took one observable liberty with the Monaco photograph and added a second column of smoke that rises from the stack of a distant building (figure 57).

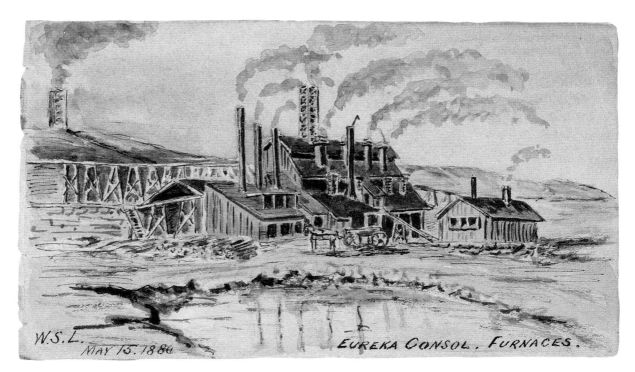

55. *Eureka Consolidated Furnaces. May 15, 1880.*

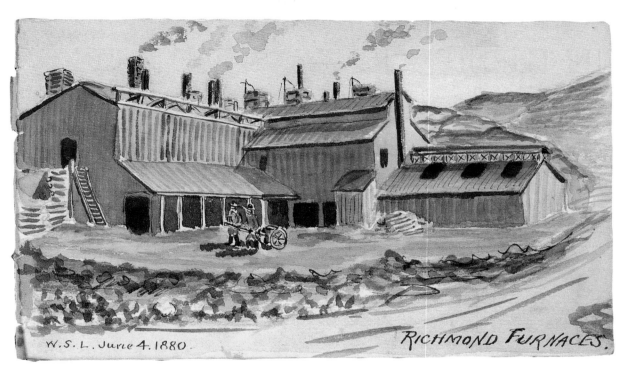

W.S.L. June 4. 1880.

RICHMOND FURNACES.

56. Richmond Furnaces. June 4, 1880.

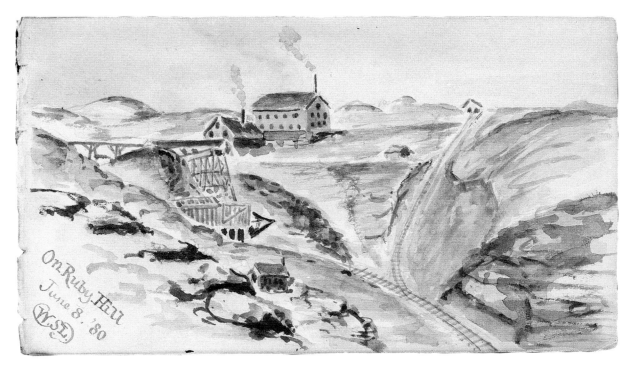

57. On Ruby Hill. June 8, 1880.

That Long copied a few of Monaco's photographs should not prompt skepticism regarding the value of this collection of watercolors. If anything, it provides a broader view of the artist's method of working. The copies were, in all probability, executed indoors, perhaps in Long's office, or even in Monaco's photography studio and are of interest especially in that Long provided color for Monaco's monochromatic images.

In and Around Eureka, May 1880

There were five fire companies in Eureka during the time that Walter Long was a resident. The first company, Eureka Hook and Ladder Company No. 1, was organized by the citizenry in October of 1871, and this was followed by another volunteer unit, the Rescue Hose Company, in the summer of 1872. Long recorded this company's firehouse on Monroe Street near the Sentinel building in May of 1880 (figure 58). He treated the frame building with precision, detailing the classic lines of the pediment over the double doors, the heavy molding of the eaves, and the timbering of the bell tower. Of equal interest in this painting is Long's depiction of the joss house next door. This building served the Chinese community in Eureka as a center for social and religious activities. Long painted the fully extended, gold fringed, red flag flying over the wooden temple with a smaller banner waving above it. The façades of nearby residences were decked with vertical red banners. Like other communities, the local Chinese population had been attracted to the region by the railroads, first during the construction of

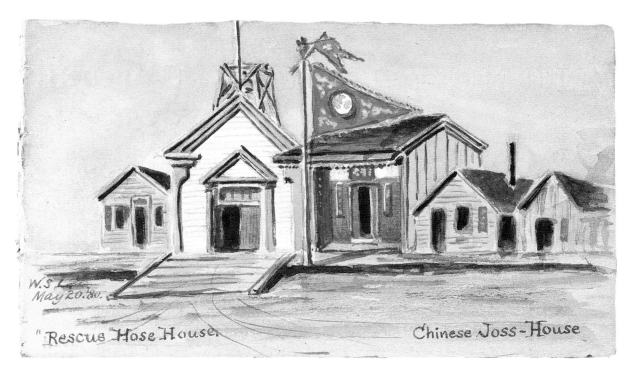

58. "Rescue" Hose House, Chinese Joss House. May 20, 1880.

the Central Pacific Railroad and later the Eureka and Palisade. "Although mining and smelting enterprises in Eureka did not employ the Chinese, work was available as cooks, domestics, laborers and woodcutters."[13] The Chinese remained tight knit during the period when Long recorded their place of worship, in part because anti-Chinese campaigns in California had created fears among some of Eureka's white citizens that the Chinese might be driven over the Sierra Nevada and into the central part of Nevada.

The "'Hooks & Knicks' Engine House" (figure 59), otherwise known as the Knickerbocker, was a pink structure complete with double doors topped by Romanesque glass windows and two cupola-like additions at the corners of the roof.

During this time, Long seemed intent on documenting specific buildings around Eureka. In addition to the firehouse, he painted the Eureka Opera House (figure 60), the courthouse, a city block that included the Eureka House in which he maintained an office, and several of the larger mining and milling operations. Long chose, in most of these paintings, to omit references to the kinds of human activity that might be seen in the streets.

In mid-1880, Long began to take more artistic license than in the past, starting to leave out or at least to soften passages in scenes, choosing to place more emphasis on his primary subject. In the process, the artist replaced hills and adjacent structures with sweeping blue skies or indistinct backgrounds. These watercolors are, from an artistic standpoint, more satisfying, and represent the efforts of a more confident artist.

13. Earl, *Eureka's Yesterdays*, p. 6.

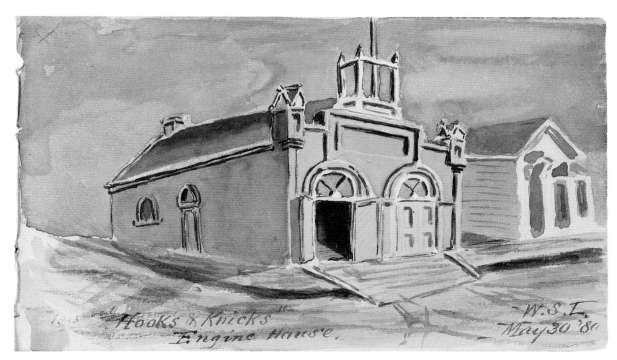

59. *"Hooks & Knicks" Engine House. May 30, 1880.*

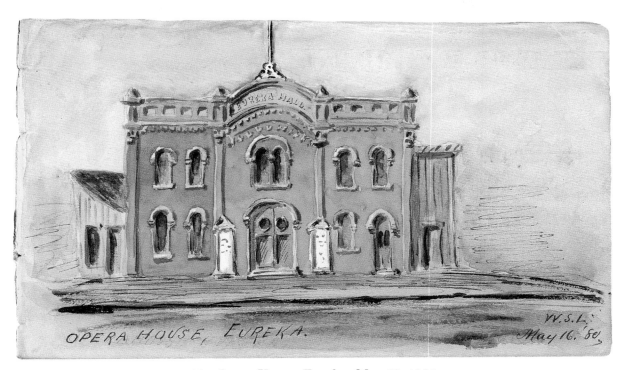

60. *Opera House, Eureka. May 16, 1880.*

Final Sketches, June 1880

In the middle of June 1880, Long's attention to the third sketchbook seemed to waver. A painting titled "Jackson Mine Hoisting Works" (figure 61), possibly a copy of another Monaco photograph, is the last dated work in the sketchbooks. The three pages immediately following this painting contain unfinished studies. The first of these last works is "Italian Ranch" (figure 62); in it Long offered a clear example of how he employed a pencil to establish the composition for his paintings. His line work was notational and rapidly achieved, and for some reason the artist chose to leave the piece in an unfinished state. Reveille, a mining camp located in Nye County some seventy miles east of Tonopah, was the subject of the next drawing (figure 63). It is evident that Long wanted to make this a fully developed watercolor, but in the final analysis he only washed in the blue of the sky before abandoning it. Long's study of Red Bluff Spring (figure 64) near the Lincoln County line was even briefer. There is a faint suggestion of a structure on the left; Long may have been in a hurry – the unfinished state of this drawing seems more the result of a lack of time than an artistic decision. Whatever the reason for the artist's inability to complete these works, he left a number of pages blank in the back of the third sketchbook – an echo of the acknowledgment in his poem to Miss Parker that the book was "unfinished."

Assessment

An assessment of the watercolors of Walter Long must take into account a number of factors.

The sketchbooks, because they remain an isolated phenomenon in Walter Long's life, must be judged principally on their own merit; they do not, at the present time, lend themselves to a study of Long's overall development as an artist. It is possible, however, to examine

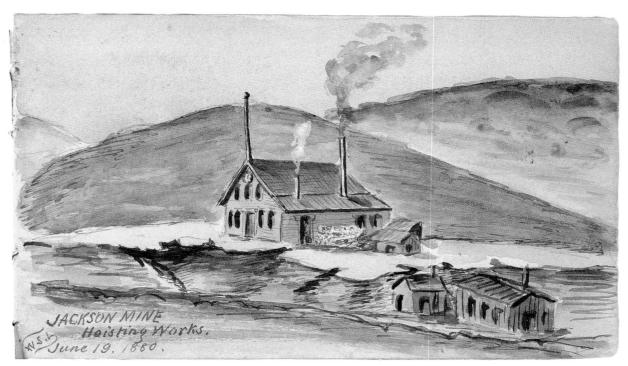

61. Jackson Mine Hoisting Works. June 19, 1880.

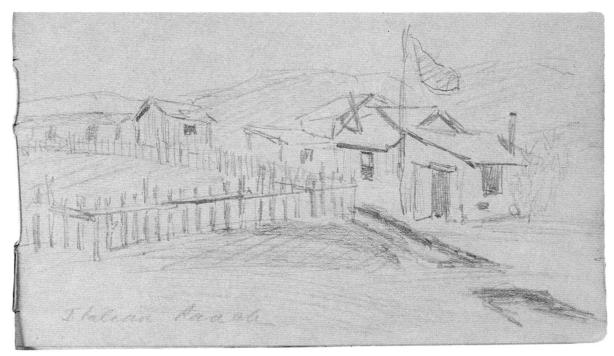

62. Italian Ranch. 1880.

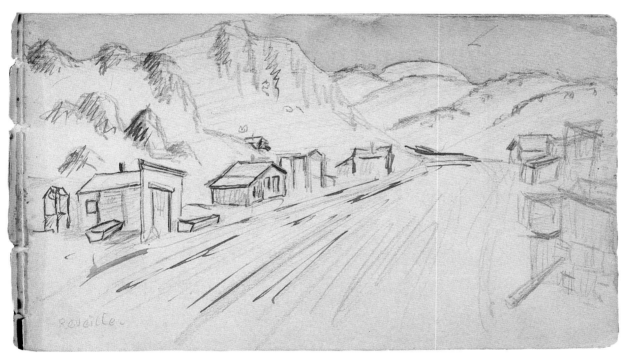

63. Reveille. 1880.

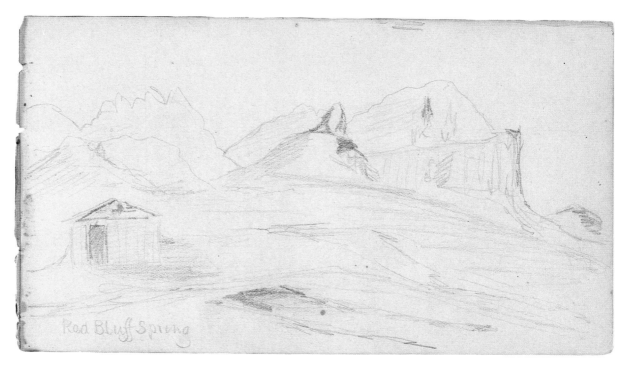

64. *Red Bluff Spring. 1880.*

the watercolors with a critical eye and to make some observations regarding his perception and methods.

The book dealer's original judgment in 1970 that Long was an American primitive seems, upon reflection, to miss the mark. The qualities that typify this tendency in the visual arts are not consistent in his paintings. The difficulties that Long experienced in the early studies of Palisade and Eureka appear to be technical, not the result of naiveté or lack of training. He knew how to create the illusion of deep space (by softening edges and employing cool colors in the distant mountains) and he understood the principles of relative size and the workings of one- and two-point perspective. Relative size provides a spatial cue based on the notion that the larger an object appears in the picture, the closer it is, and vice versa; these graphic techniques were no mystery to Long.

That the vanishing points in his paintings sometimes went awry seems to have come about because of a lack of judgment rather than as a function of some innate pattern of perception. By and large, he had corrected a number of these problems by the time he finished with the third sketchbook.

Long was by no means a consummate watercolorist. In part, his selection of the small sketchbooks hindered him. In a medium that permits a broad and spontaneous application of color, the artist seemed constricted in his manner of working. With the small format, Long's brushstrokes traveled a controlled distance but they seldom took on the luminosity that can be obtained when an artist freely washes his colors over the white, pebbled paper (as in the works of American painters Winslow Homer and John Marin). Long's application of color grew more adventuresome in the third sketchbook and these images seem to reflect a more relaxed and confident manner. In his studies of Eureka during May and June of 1880, the artist was less

inclined to show everything he was observing, and by eliminating extraneous details he was able to more effectively depict the subjects that attracted him.

Long's contribution to mining history will probably be recognized more for its intimacy than for its documentation of a turbulent industry. He operated without a grand scheme; he did not maintain the kind of intentions that had spurred the photographers who were common practitioners in and around the mining towns of the West. Long seldom dealt with the workers in the mines and smelters, and when he did his watercolors were studies of small operations, a few miners going about their daily tasks in an unposed, matter-of-fact way. Nor did he concern himself with the people of Eureka or Tempiute. It is almost as if Long had painted the streets of these towns after the citizens had moved on to the next bonanza.

In one sense, the book dealer was right. Long followed a course that differed from the photographers and painters who tended to treat the West in more grandiose ways. Long's watercolors expose places that were off the beaten path. He seemed content to set up his studio, as it were, where he happened to be.

If Long's sole intention was to create his paintings for the eyes of Miss Parker, then his sketchbooks can be valued as a diary, created in visual terms with notations about time, place, and mood. The artist's training as a civil engineer and his respect for order combined to strengthen the documentary nature of these paintings. And it is this duality, the unique blend of the personal with the formal, that can heighten the viewer's appreciation of the watercolor sketches of Walter S. Long.